interesting

It must have

ood pencil

Keith Richards

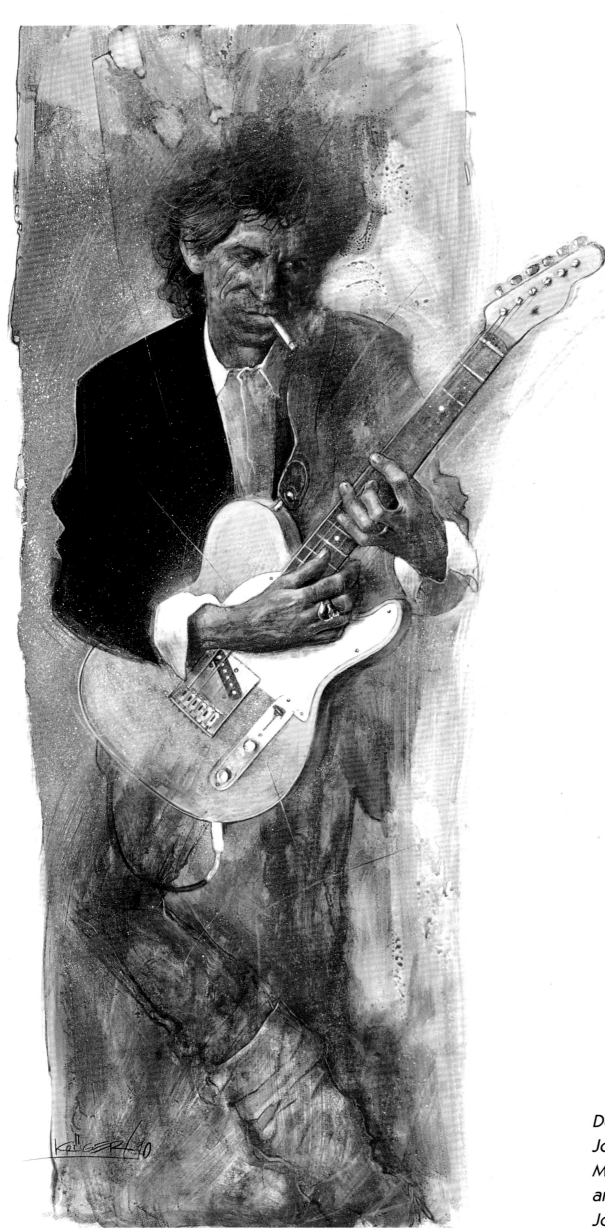

Dedicated to
Jo's husband
Marlon's father
and
Johannes P. W.

Für
Jo's Ehemann
Marlon's Vater
und
Johannes P. W.

KRÜGER

STONES

MORPHEUS
INTERNATIONAL

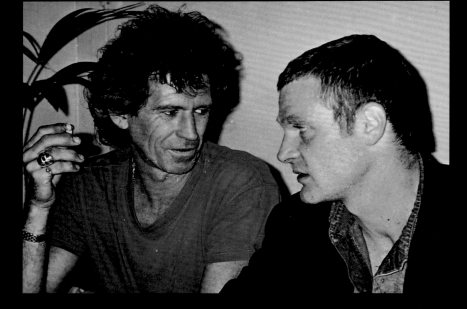

Sebastian Krüger (seen here with Keith Richards in Berlin) was born in
1963.He went almost directly from being an art student to beginning a
successfull career as a freelance caricaturist, illustrator and painter.
His works can be seen on the covers of such international publications
as SPIEGEL, STERN (Germany) and L'ESPRESSO (Italy), as well as on
various music magazines and record covers. Krüger has had three books
published prior to this one and has a yearly calendar called "Stars" relea-
sed by Lappan Verlag of Oldenburg, Germany. This large format calendar
contains some of his most spectacular art work. His paintings have been
displayed at a number of expositions, including an extensive showing in
November, 1994 at the Wilhelm-Busch-Museum in Hanover, Germany.

Sebastian Krüger (hier mit Keith Richards in Berlin), Jahrgang 1963,
begann 1986 direkt nach seinem abgebrochenen Studium der Freien
Malerei freiberuflich als Karikaturist, Illustrator und Maler zu arbeiten.
Mit Erfolg. Seine Bilder sind inzwischen auf den Titelblättern von SPIEGEL,
STERN und L'espresso (Italien) genauso zu sehen, wie auf Satire- und
Musikzeitschriften und LP-/CD-Covern zahlreicher Rockgruppen.
Bisher sind drei Bücher mit seinen Arbeiten erschienen, und Jahr für Jahr
bringt der Lappan Verlag einen großformatigen Kalender „Stars" mit sei-
nen spektakulärsten Bildern heraus. Zahlreiche Ausstellungen, darunter
eine große Werkschau im Wilhelm-Busch-Museum in Hannover im
November 1994.

© 1994 by Edition C
Edition Crocodile AG, P.O. Box 4031, CH-6304 Zug, Switzerland, Fax (+411) 262 45 14
For information, address the Publishers; Peter Baumann and Dieter Schwa m
Distributed to the European book trade by Lappan Verlag GmbH, P.O. Box 3407, D-26024 Oldenburg, Germany, FAX (+49-441) 980 66 22
Distributed to North America and the United Kingdom by Morpheus International
Layout: Peter Baumann and Peter Schwalm Cover: Christian Sonnhoff
Text and translation: Andrea Faustmann
Foreword: Wolfgang Niedecken/Translation: Linda M. Golding
Reproductions: litho niemann + m. steggemann gmbh, D-Oldenburg
Harlan Ellison text © 1969 by The Kilimanjaro Corporation. All rights reserved.

First Morpheus edition: August 1996
ISBN 1-883398-61-4

Published by
MORPHEUS INTERNATIONAL
125 E. Reno Ave., #17, Las Vegas, NV 89119
Tel (702) 233-3339 Fax (702) 739-3331
www.morpheusgallery.com & www.krugerstars.com

Printed in Singapore
North American distribution by Publishers Group West
Contact Sebastian Kruger via Becker! Illustrators, Hartmut Becker, Lerchenstrasse 100, D-22767 Hamburg, Germany

Foreword/Vorwort

Our tour came to an end two weeks ago and the first withdrawal symptoms are just making themselves felt when I find in my mountain of mail an invitation to Sebastian Krüger's exhibition at the Dumont Studio in Cologne. The artist will be there himself, I take out my diary and mark the date boldly. The gaping wide Jagger mouth with its threads of saliva, Keith Richards with a Jagger glove puppet, drawings, paintings - the guy who apparently produces this kind of stuff effortlessly interests me. A few days later the date arrives. As I enter the Studio an amazingly honest lady is in the middle of the welcoming speech, leaving no doubt about the fact that she personally has not a tittle to do with Rock'n Roll in general and the Stones in particular. Perhaps she should just keep quiet if she wants to be regarded as a philosopher in future, too, I think, and grin to myself about the tremendously tall chap next to her, who notices me at that moment, too and is visibly glad to see me. At last ... the speech is over - he comes up to me and I feel as if I am meeting an old friend. He guides me through his exhibition, answers all my technical questions about the portraits with commendable patience, and at a favourable moment I pluck up my courage and ask him if he could imagine painting our next cover... The rest is history.

This morning, the parcel post delivery drags me out of bed. It is a dummy of Sebastian's new Stones book - for which I am to write the foreword. On leafing through I find it is just as I hoped it would be: every inch of me wants to chuckle, I practically purr with pleasure. I go through the book 10, maybe 20 times, greet familiar pages, am exhilarated by new ones, and am reassured to discover that my friend has remained true to himself. HIS Stones hierarchy stands just as firm as it ever did. But what am I writing?... Anyone with eyes in his head can see for himself. Well over half the book consists of the most subtle studies of the man who embodies Rock'n Roll like no other on earth. Keith Richards as penitent, as gunslinger, as Jack Daniels consumer, smoking, grinning, with a black look, 1000 wrinkles, furrows, and forever lovingly caressing his Telecaster. No - it is totally obvious who Krüger's favourite Stone is. But Ron Wood seems to have clowned his way into his heart, too. Wonderful, the game with the three pink details on page 27, fantastic, his expression framed between the all-powerful Glimmer Twins on page 8.

Charlie, the drumming gentleman, always appears totally introverted in Sebastian's works, in complete contrast to the lead singer, whose ability to attract affection seems to be equivalent to that of Gladstone Gander. Always a touch over the top, posing, vain, foppish, whether with erect finger or with gaping mouth as pars pro toto. Never cheaply overdrawn, however, but always dissected with the respect which he after all deserves.

Well, to come to an end: Bill Wyman appears, too ... to have taken part (...it appears that the Olympic spirit applies literally here), Brian Jones hails once again from the other side and a centerfold to rend a heart of stone shows two worthy Rock'n Roll monoliths, frozen as in a snapshot, interrupted talking shop, primary rock material.

So what ?... Even if malicious tongues will claim that I have now mutated to a copy-writer, I must say in all fairness to the truth: simply brilliant, this stuff!!

Wolfgang Niedecken
Cologne, 26 May 1994

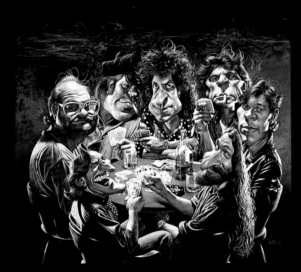

The German rock group BAP - Wolfgang Niedecken in the middle. This picture by Sebastian Krüger was the cover motif on the group's last CD and tour poster.

Die deutsche Rockgruppe BAP - in der Mitte Wolfgang Niedecken. Dieses Bild von Sebastian Krüger war das Cover-Motiv der letzten CD und des Tournee-Plakates.

Unsere Tournee ist grade mal zwei Wochen vorbei, erste Entzugs-Symptome machen sich bemerkbar, da finde ich in meinem Postberg die Einladung zu Sebastian Krügers Ausstellung im Kölner Studio Dumont. Der Künstler ist anwesend, sage ich mir, zücke meinen Kalender und trage den Termin fett ein. Das weit aufgerissene Jaggermaul mit Speichelfaden, Keith Richards mit Jagger-Handpuppe, Zeichnung, Malerei: der Typ, der sowas anscheinend aus dem Handgelenk schüttelt, interessiert mich. Paar Tage später ist es soweit. Wie ich reinkomme, hält gerade eine erstaunlich ehrliche Dame die Begrüßungsansprache, keinen Zweifel darüber aufkommen lassend, daß sie persönlich mit Rock'n Roll im Allgemeinen und den Stones im Besonderen nicht die Bohne am Hut hat. Vielleicht sollte sie schweigen, um weiterhin als Philosophin zu gelten, denke ich und grinse innerlich über den baumlangen Kerl neben ihr, der mich jetzt auch bemerkt und sichtlich erfreut ist, mich zu sehen. Geschafft ... die Rede ist vorbei - er

kommt auf mich zu, und mir kommt es vor, als träfe ich einen alten Bekannten. Der führt mich durch seine Ausstellung, beantwortet mir geduldig sämtliche technischen Fragen bezüglich seiner Portraits, und in einem günstigen Moment fasse ich mir ein Herz und frage ihn, ob er sich vorstellen könnte, unser nächstes Cover zu malen ... Der Rest ist Geschichte.

Heute morgen schmeißt mich der Paketbote aus dem Bett. Es ist ein Handmuster von Sebastians neuem Stones-Buch - noch mit Blindtext -, für das ich das Vorwort schreiben soll. Beim Durchblättern ist es dann genauso, wie ich's erhofft hatte: Ganzkörperschmunzeln meinerseits, wohligstes Gefühl macht sich breit. Gehe das Werk ca. 10 bis 20 mal durch, begrüße Vertrautes, begeiere mich über Neues und stelle beruhigt fest, daß mein Freund sich treu geblieben ist. SEINE Stones-Hierarchie steht fest wie eh und je. Aber was schreibe ich? ..., wer Augen hat, sieht's selber. Weit über die Hälfte des Buches besteht aus subtilsten Studien des Mannes, der den Rock'n Roll verkörpert wie kein zweiter. Keith Richards als Büßer, als Revolverheld, als Jack Daniels-Konsument, rauchend, grinsend, finster dreinblickend, 1000 Falten, Furchen und immer wieder verliebt seine Telecaster bearbeitend. Nein - wer Krügers Lieblingsstone ist, bleibt unübersehbar. Aber auch Ron Wood scheint sich in sein Herz gekaspert zu haben. Wunderbar, das Spielchen mit den drei pinkfarbenen Details auf Seite 27, unglaublich sein Blick, eingerahmt von den übermächtigen Glimmer Twins auf Seite 8.

Charlie, der trommelnde Gentleman, wirkt in Sebastians Arbeiten immer vollkommen introvertiert, ganz im Gegensatz zum Vorsänger, dessen Sympathieträgertauglichkeiten anscheinend irgendwo in der Nähe von Gustav Gans angesiedelt sind. Immer einen Touch drüber, posierend, eitel, geckenhaft, ob mit erigiertem Zeigefinger oder mit aufgerissenem Maul als pars pro toto. Aber auch er nie billig überzeichnet, sondern stets mit dem Respekt seziert, der ihm ja nun mal zusteht.

Na gut, um zum Schluß zu kommen: Bill Wyman kommt auch vor ... dabei gewesen (... hier kommt wohl ausschließlich der olympische Geist zum Tragen), Brian Jones grüßt nochmal aus dem Jenseits, und ein steinerweichendes Centerfold zeigt zwei ehrenwerte Rock'n Roll-Monolithen, eingefroren wie in einer Momentaufnahme, beim Fachsimpeln unterbrochen, Urgestein unter sich.

Was soll's?... Auch wenn böses Zungen behaupten werden, ich sei zum Werbetexter mutiert, der Wahrheit die Ehre: schon genial, das Zeug!!

Wolfgang Niedecken
Köln, 26. Mai 1994

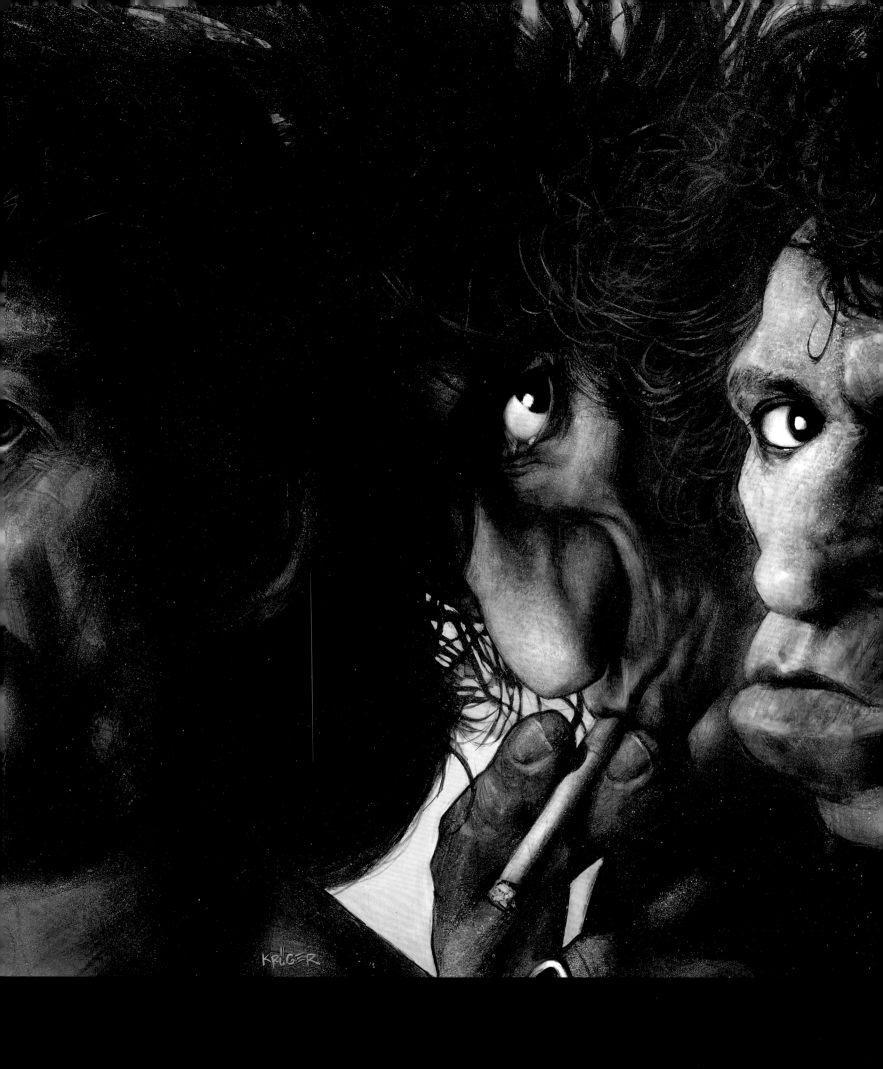

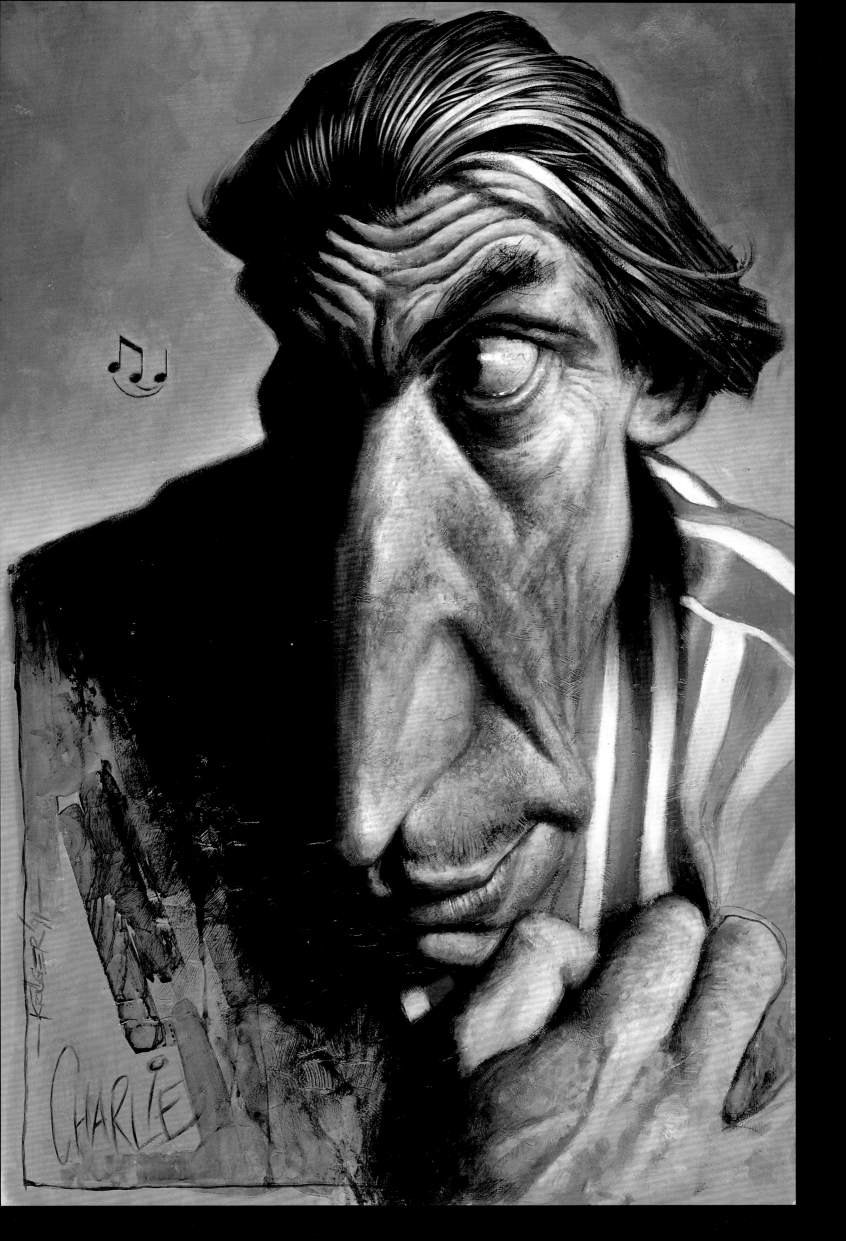

"We went backstage and Mick was sitting there in his dressing gown and he was so much smaller than I'd imagined . . ."

Jerry Hall

"People find it hard to accept multifaceted people---that you can be a person who has children but yet can go out and get wild and crazy and mad and drunk, and then go out on the road and be completely sober because that's what you have to be . . . I don't find life quite so simple, that everyone's just got these tiny personalities and that they can only behave in one kind of way."

Mick Jagger

"I suddenly recall a special moment when I was on tour with the Rolling Stones, several years ago. We were in Sacramento, I believe (after three days of gigs-and-planes I couldn't tell San Jose from San Diego except San Jose is where we had to go out of the stadium in an armored car because the crowds were so big and ruthless). It was a twitchy crowd that had filled the auditorium. Rows of cops up and down the aisles. The groupies and teeny-boppers were pitched at the fracture point. They'd run out of jellybeans to throw on the stage and had started tossing underpants, bras, Kotex, jewelry, anything that wasn't hammered down. The preliminary acts had come and gone, and now the Stones were on. You couldn't even hear them. The crowd noise---from where I stood in the wings---was like the sound of waves washing up on the beach. Or maybe like that of a wounded animal. A riot broke out in back. Cops put it down. The manager was getting uptight. His auditorium was hung with tapestries and expensive drapes. He went from uptight to outright terrified when three young birds boiled out of the audience and tried to climb over the wheelchair cases in front

in an attempt to leap the orchestra pit and get on stage. He came over to me and whispered, 'Are you with them?' I nodded that I was. 'Look, tell this one nearest you'---he meant Bill Wyman, who was closest to the stage-right wing---'tell him I'm going to lower the fire curtain . . . and they should step back three paces so it doesn't hit them.' I said okay, and when Bill caught my signal and moved close enough for me to howl the instructions over the music and the crowd noise, I gave the word. He nodded, and passed it down the line to Brian Jones, Keith Richards and Mick Jagger. Charlie Watts, the drummer, was already well back of the drop-point. Three paces back is what the manager wanted.

Mick and Brian Jones took three steps forward. It was now virtually impossible to seal the stage . . . and the crowd was getting crazier. Then Mick started to tease the girls. He moved sinuously, getting them even more turned-on, if that was possible, then he slowly stripped off his jacket, wriggling out of it while holding the hand-mike. As they shrieked and moaned to be thrown the incredible souvenir of their love-idol, Mick folded the jacket into a little square, and held it out over the footlights. The girls tore their hair and cried and beat the arms of their seats. The sound climbed till you could hear nothing but the blood pounding in your temples. And just when the animal horde thought they were going to get the jacket, he spun neatly and dropped it onstage behind him. Then they broke and ran. Hundreds of them. They came right through the cops, slamming them into the walls. They went over the seats, and hit the row of cripples in their wheelchairs like a Kansas twister. The first onslaught of young girls fell into the orchestra pit and the others went right over their backs like troops crossing barbed wire on the backs of

their buddies. (I heard a report that there were fifteen broken backs in that batch.)

It was crazy as sixteen battlefields. Screaming, sliding chicks, crawling on their bellies across the stage---and the Stones were already gone. They were by that time in the basement, going out a service door, into an unmarked little compact car (the kids would never suspect it was the getaway vehicle, because the decoy Continental was parked in front of the stage door), and were out of the area, on the way to the airfield, where their private plane was already warming up. But back in the theater, a thousand mindless little hippie mommas were tearing that jacket to shreds, and themselves in the bargain.

. . . I remember, and have the insight (not for the first time) that there was nothing noble in Mick Jagger's "tease." He didn't take those three steps forward, rather than back, because he cared about his audience and wanted those kids to get their money's worth. He despised the kids. Traveling with the group for three days I could understand why. The fans were as filled with love and adoration as the cannibals who tore Sebastian to shreds and ate him in Suddenly, Last Summer. They were a mindless, slavering horde; individually they were lovely kids, but jammed together they were as terrifying as the marabunta, the army ants. Jagger despised them, and he had goaded them purposely into wreaking his vengeance on themselves---as well as $160,000 worth of damage to the theater. It was a mind-croggling demonstration of the love/hate relationship between superstars and their insatiable fans."

Harlan Ellison
"The Glass Teat," 1969

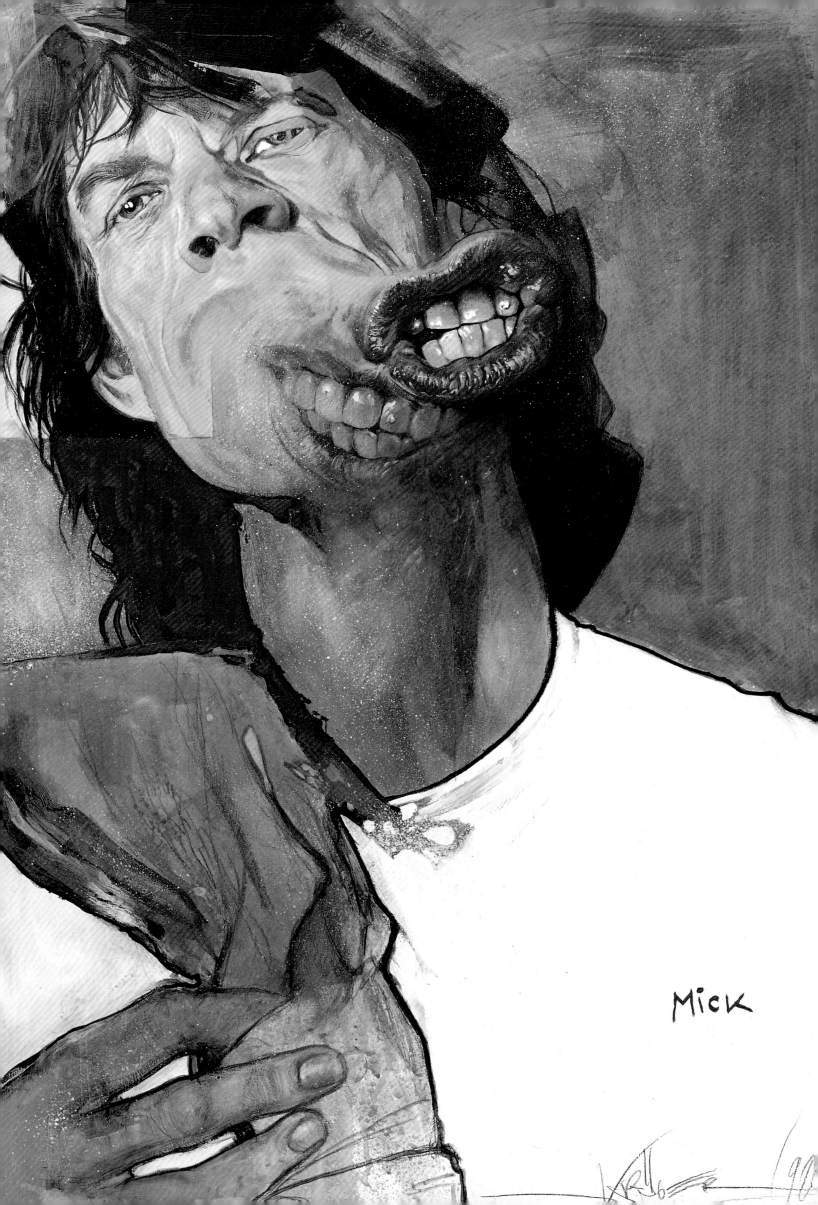

MICK

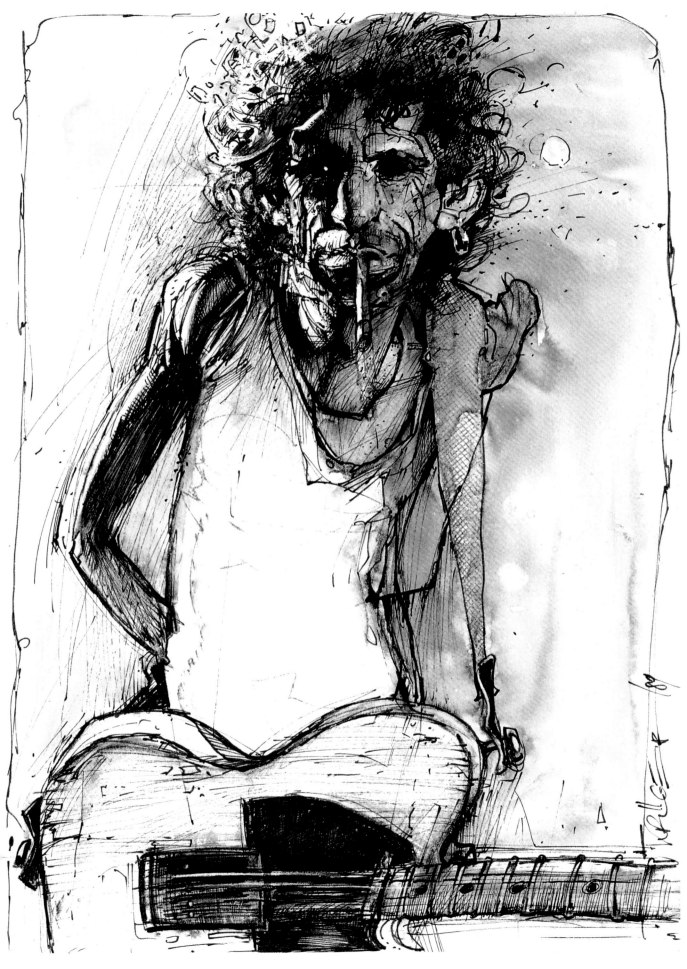

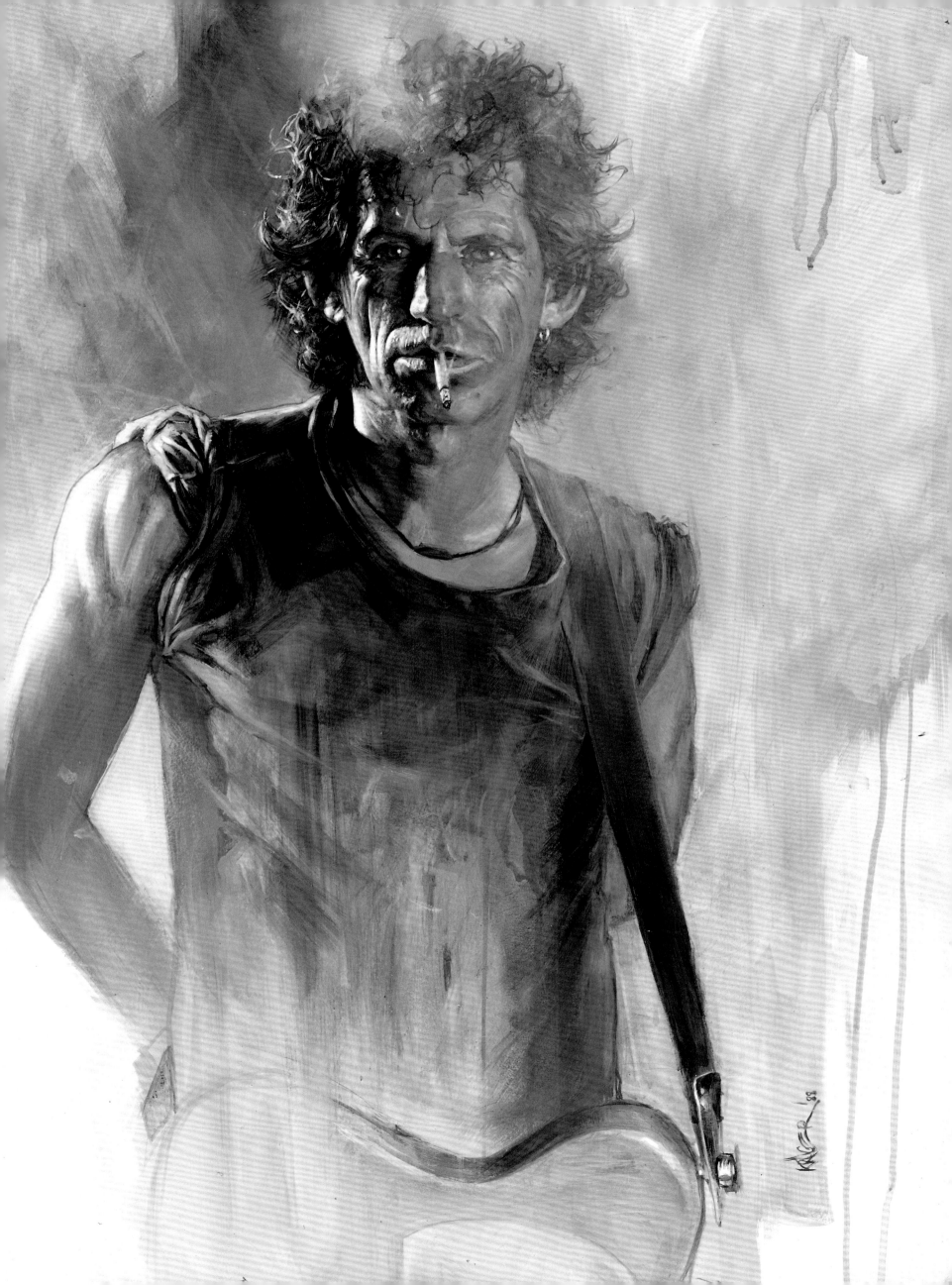

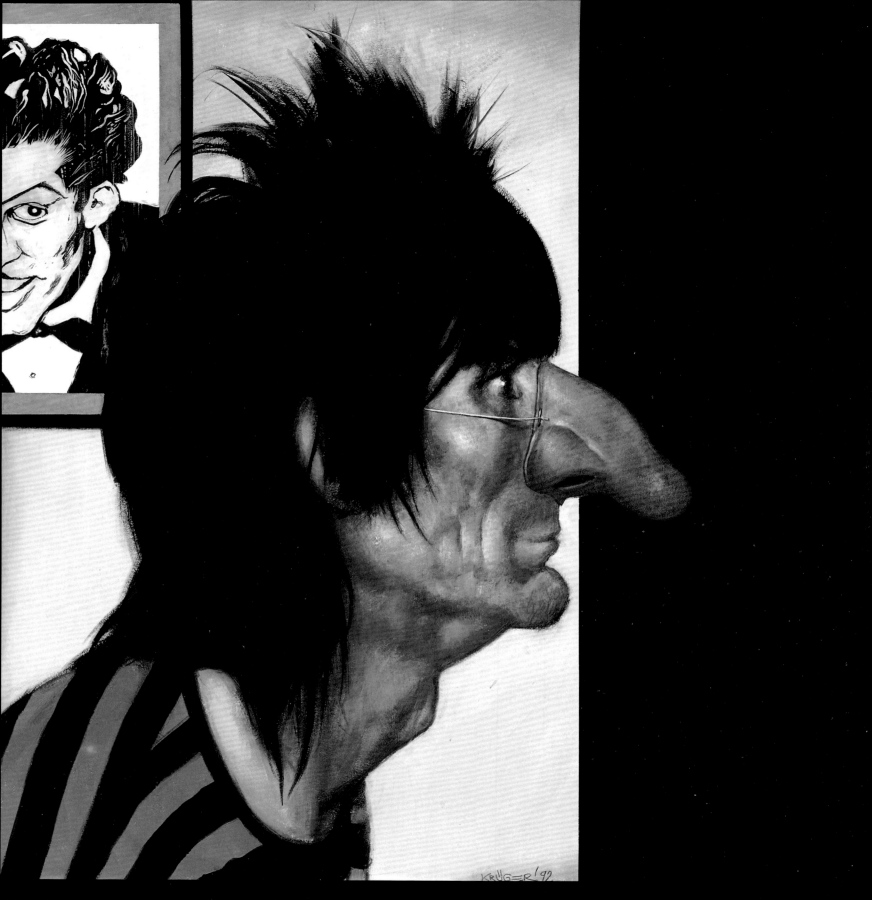

"Charlie's wearing his age like all those great jazzers. He's aging the way Ellington did, Count Basie, too. Real grace, class. Even the way he dresses now. He had to put up with some tough times recently in the family department. He was under a lot of strain for a while, but he'd let it out by coming into the studio and pounding the shit out of the drums.

He's such a class act. A real inspiration to play with. When he's on, the whole band is on. Absolutely indispensable." Ron Wood

„Charlie geht mit dem Älterwerden wie alle großen Jazzer um. Er altert so wie Ellington und auch Count Basie. Mit echter Würde und Klasse. Sogar wie er sich jetzt anzieht. Kürzlich hat er eine ganze

Menge mit seiner Familie durch-gemacht. Er stand eine Weile ziemlich unter Streß, aber er hat alles rausgelassen, indem er ins Studio kam und beim Trommeln den ganzen Mist losgeworden ist. Er ist ein Klasse-Typ. Eine echte Inspiration, mit ihm zu spielen. Wenn er loslegt, legt die ganze Band los. Absolut unverzichtbar." Ron Wood

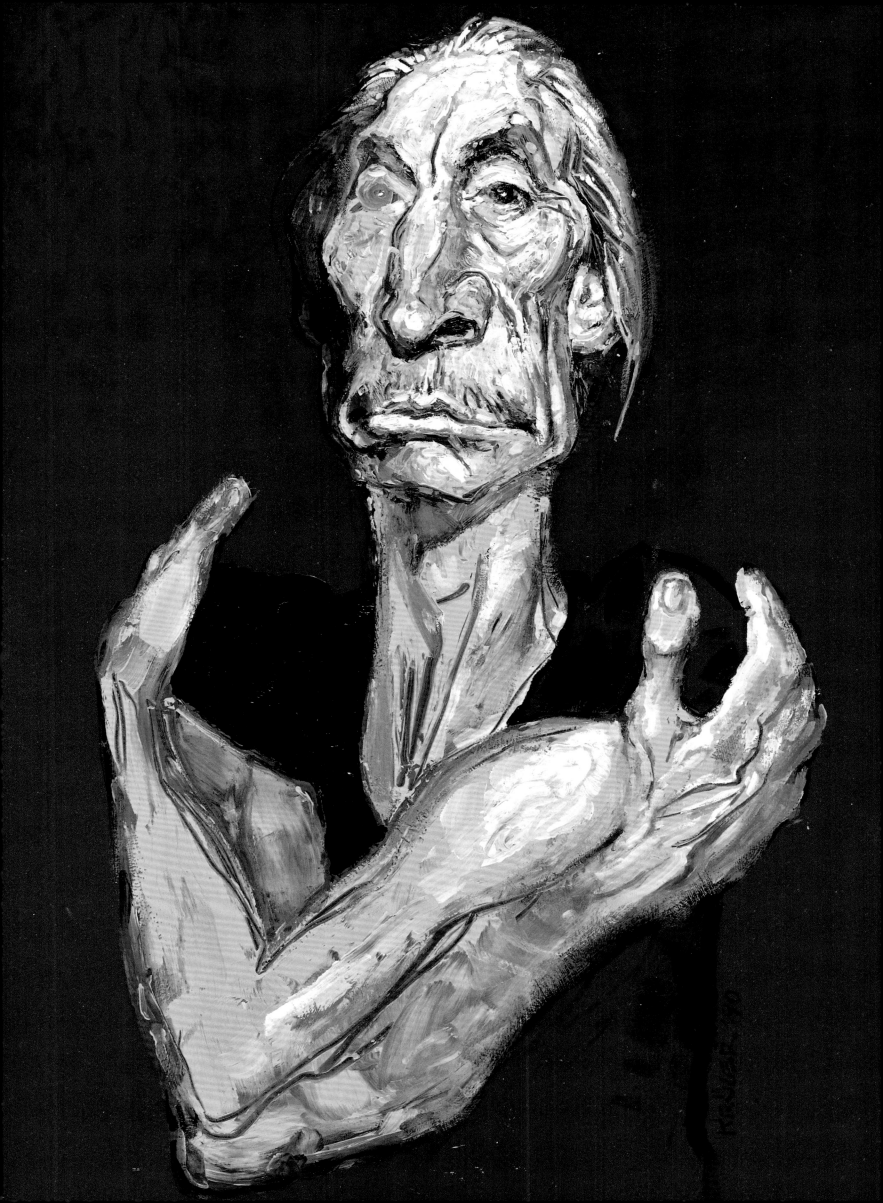

"Joe the Dead lowered the rifle, like some cryptic metal extension growing from his arm socket, and smiled for a fleeting moment. A blush touched his ravaged features with a flash of youth that evaporated in powder smoke. With quick, precise movements he disassembled the telescoping rifle and silencer and fitted the components into a toolbox. Behind him, Kim Carsons and Mike Chase lay dead in the dust of the Boulder Cemetery. The date was September 17, 1899. Joe walked away from the Cemetery, back toward Pearl Street and the center of town, whistling a dry raspy little tune like a snake shedding its skin. He made his way to the train station, bought a ticket to Denver and took a shot of morphine in the outhouse. Two hours later he was back in his Denver stronghold. No regrets about Kim. Arty type, no principles. And not much sense. Sooner or later he would have precipitated a senseless disaster with his histrionic faggotries ... a chessman to be removed from the board, perhaps to be used again in a more advantageous context."

W. S. Burroughs
"Western Lands", 1987

„Der tote Joe ließ das Gewehr sinken, das ihm wie ein rätselhafter metallener Fortsatz aus dem Schultergelenk zu wachsen schien, und ein Lächeln huschte über sein Gesicht. Ein Hauch von Farbe, der seine verwüsteten Gesichtszüge plötzlich wieder jung erscheinen ließ, verflüchtigte sich im Pulverdampf. Mit raschen, präzisen Bewegungen schraubte er den Schalldämpfer ab, zerlegte die Waffe und verstaute die Teile in einem Werkzeugkasten. Hinter ihm lagen Kim Carsons und Mike Chase tot im Staub des Friedhofs von Boulder. Man schrieb den 17. September 1899. Joe verließ den Friedhof, und während er zurück zur Pearl Street und dem Stadtzentrum ging, pfiff er eine rauhe, trockene Melodie vor sich hin. Es klang, als wenn eine Schlange sich häutet. Im Bahnhof kaufte er eine Fahrkarte nach Denver und spritzte sich auf dem Abort eine Dosis Morphium. Zwei Stunden später war er wieder in seinem Schlupfwinkel in Denver. Kein Bedauern wegen Kim. Künstlertyp. Keine Prinzipien. Und nicht viel Verstand. Früher oder später hätte er mit seinen schwulen theatralischen Auftritten ein sinnloses Desaster verursacht. Eine Schachfigur, die man vom Brett nimmt, um sie vielleicht später unter günstigeren Bedingungen wieder einzusetzen."

William S. Burroughs
„Western Lands", 1987

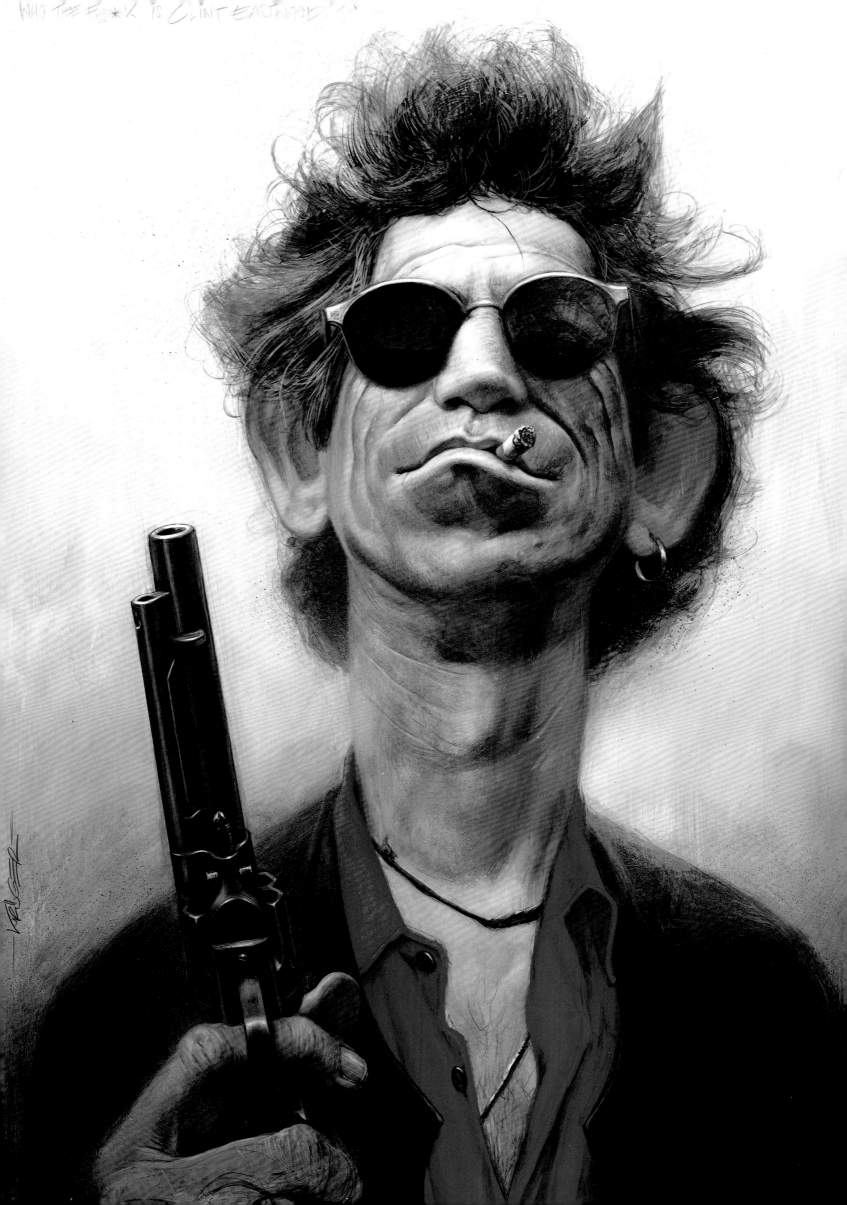
WHO THE F@*K IS CLINT EASTWOOD?

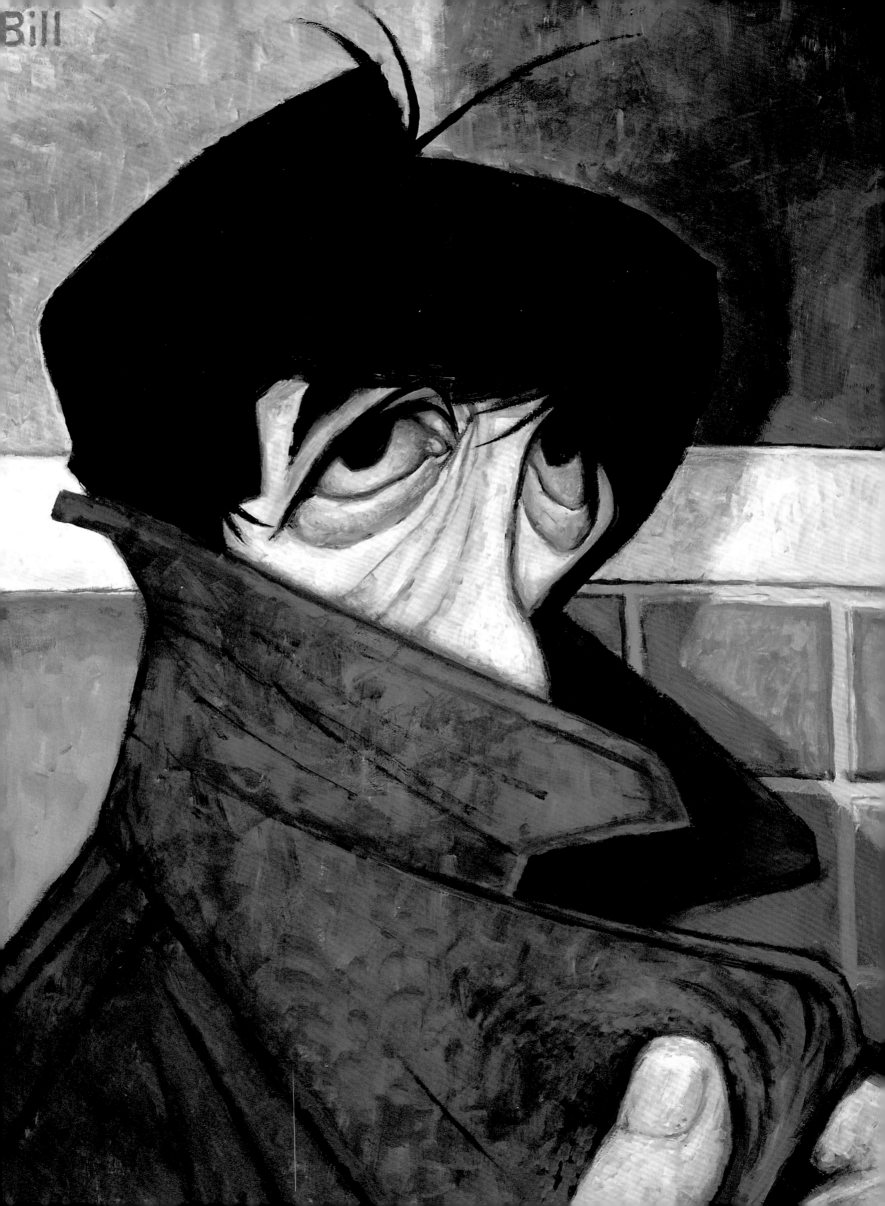

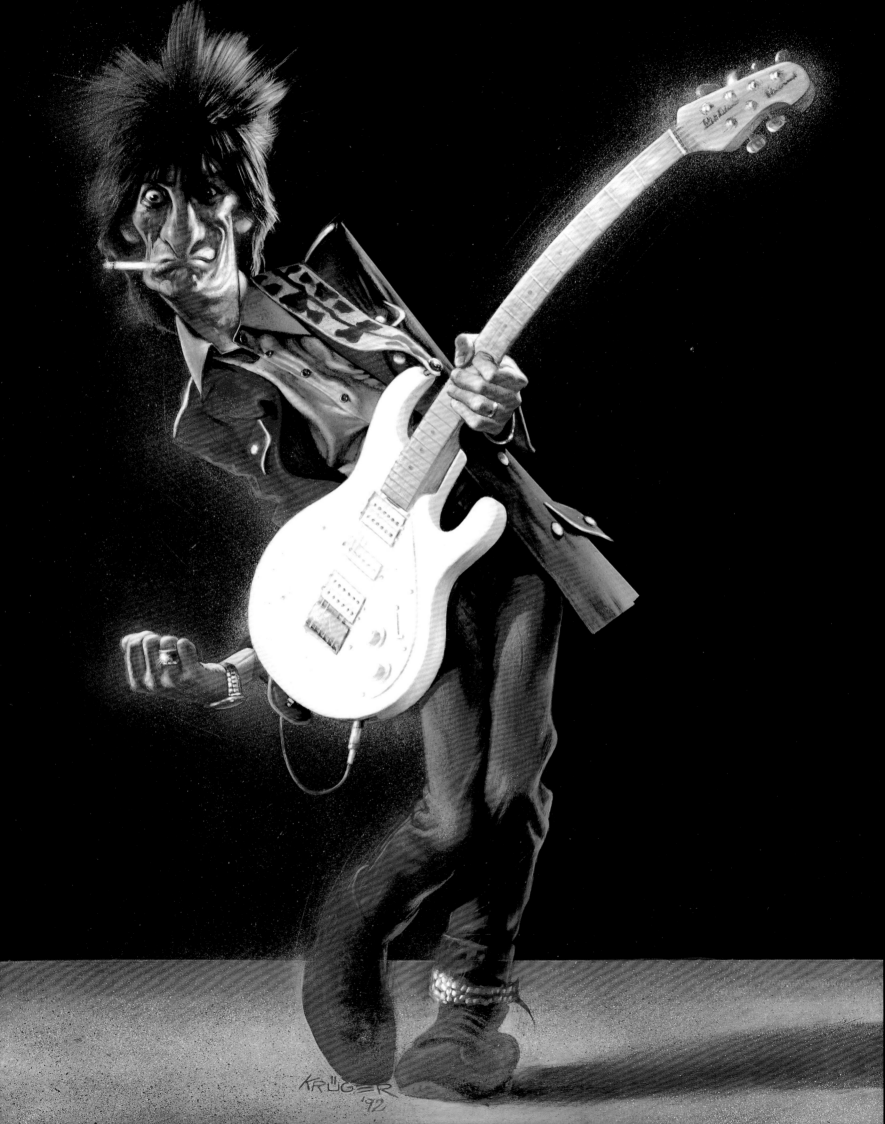

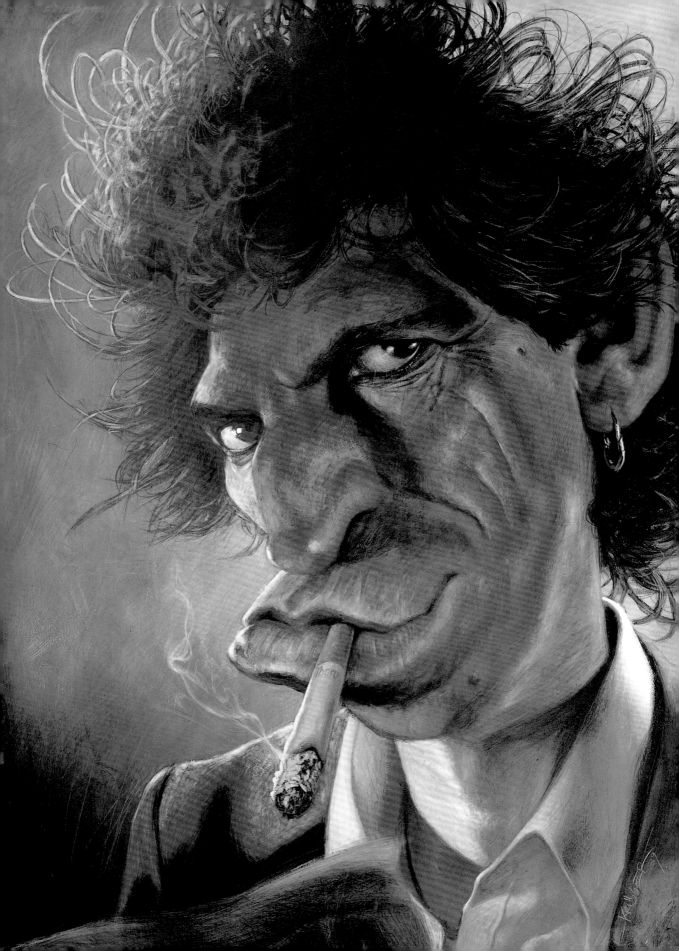

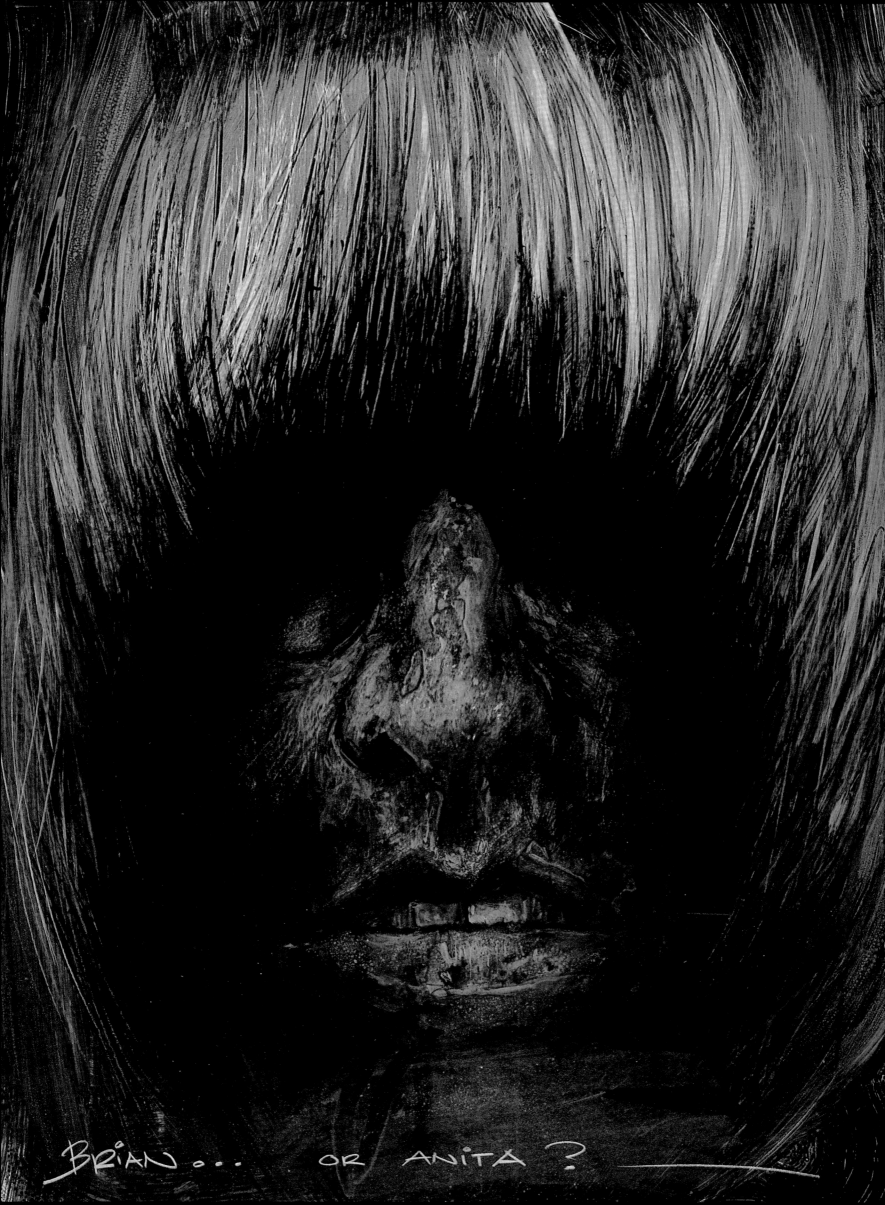

BRIAN ... OR ANITA ?

"Mick had a very different kind of showmanship, and he was different from the very beginning. One of the most interesting things about Mick as a personality, and it's a very delicate subject, is the enormous impact he has made on the world when it comes to male identification. He's basically helped to alter the whole idea of what it is to be male. He personally may not have done it, but his example has been a very, very strong one. I think you can imagine how shocking Mick was in the early days when you consider that the kind of theatricality which Mick uses is not really the kind of mannerism which you easily identify with the male role in the theater. It's more of a kind of Marilyn Monroe thing. And, frankly, it was wildly embarrassing first time round with it."

Alexis Korner

„Mick wußte sich von Anfang an geschickt in Szene zu setzen. Er war anders als alle anderen. Mit das Interessanteste an seiner Persönlichkeit - ein recht heikles Thema - ist sein enormer Einfluß auf die Identifikation des Mannes. Er hat wesentlich dazu beigetragen, dem Begriff ‚männlich‘ eine neue Bedeutung zu geben. Vielleicht nicht persönlich, aber sein Beispiel hat Schule gemacht. Ich glaube, man kann sich die Empörung in jenen frühen Tagen vorstellen, wenn man bedenkt, daß Micks theatralische Mätzchen eigentlich nicht viel zu tun haben mit dem gespreizten Auftreten, das man gemeinhin mit der männlichen Rolle am Theater identifi-ziert. Er erinnert mit seinem Gehabe eher an Marilyn Monroe. Und, ehrlich gesagt, anfangs war die ganze Sache recht peinlich.“

Alexis Korner

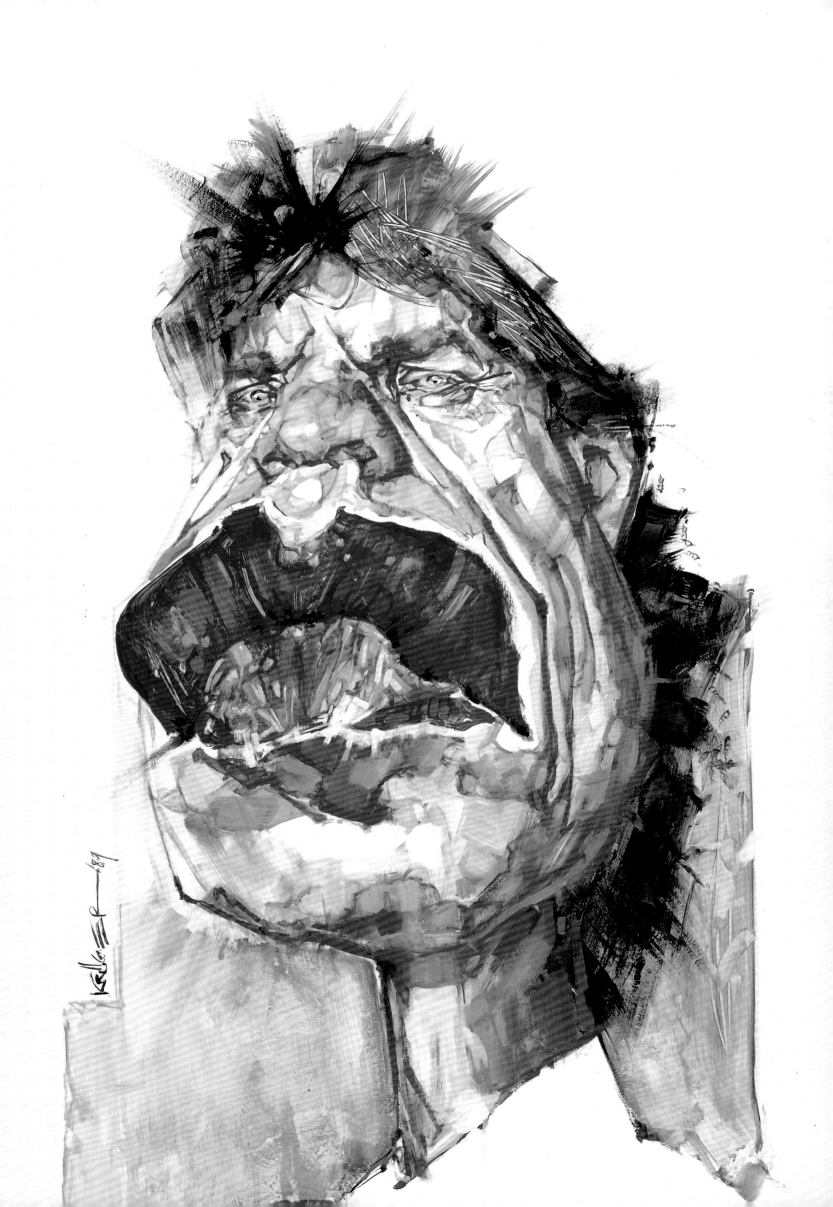

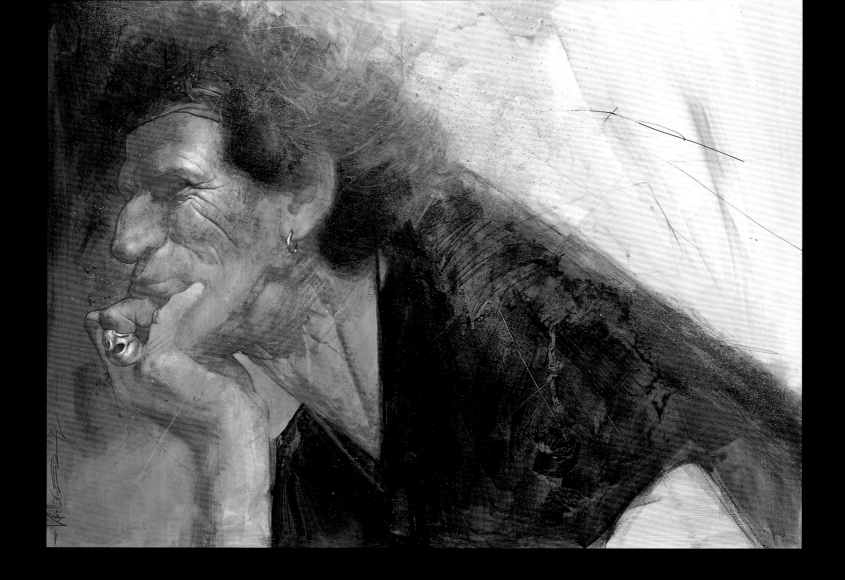

"I guess we're obsessed with showing that we can still make a better record than we've ever made, and go out and perform it as well as we ever did. Whether or not we really do doesn't matter. It's just going for it and thinking the possibility is there. We simply have to look better and sound better than anyone out there. We asked ourselves, 'Why are we doing this? Do we really want to?' And the answer was, 'We have to.' Not from the money viewpoint so much as the fact that none of us was about to let the Stones drift away. I think there is this need for us to rise to the occasion. We're still looking for the ultimate Rolling Stones. We're never going to find it, but it's like the Holy Grail. It's the quest that's important, not finding it." Keith Richards

„Ich glaube, wir sind von der Idee besessen, allen zu zeigen, daß wir nach wie vor tolle Platten machen und auch auf der Bühne unverändert unsern Mann stehen können. Ob uns das tatsächlich gelingt oder nicht, steht auf einem andern Blatt. Aber wir versuchen es halt, denn nichts ist unmöglich. Wir müssen ganz einfach besser aussehen und besser klingen als alle andern. Wir haben uns gefragt: ‚Warum machen wir das überhaupt? Wollen wir das wirklich?' Und die Antwort war: ‚Wir müssen.' Weniger aus finanziellen Gründen als aufgrund der Tatsache, daß keiner von uns tatenlos mitansehen wollte, wie die Stones auseinanderfallen. Ich glaube, wir müssen uns der Herausforderung stellen und beweisen, daß wir der Situation gewachsen sind. Wir sind immer noch auf der Suche nach den ultimativen Rolling Stones. Wir werden sie wohl niemals finden, das ist wie beim heiligen Gral. Auf die Suche kommt es an - nicht darauf, ihn zu finden." Keith Richards

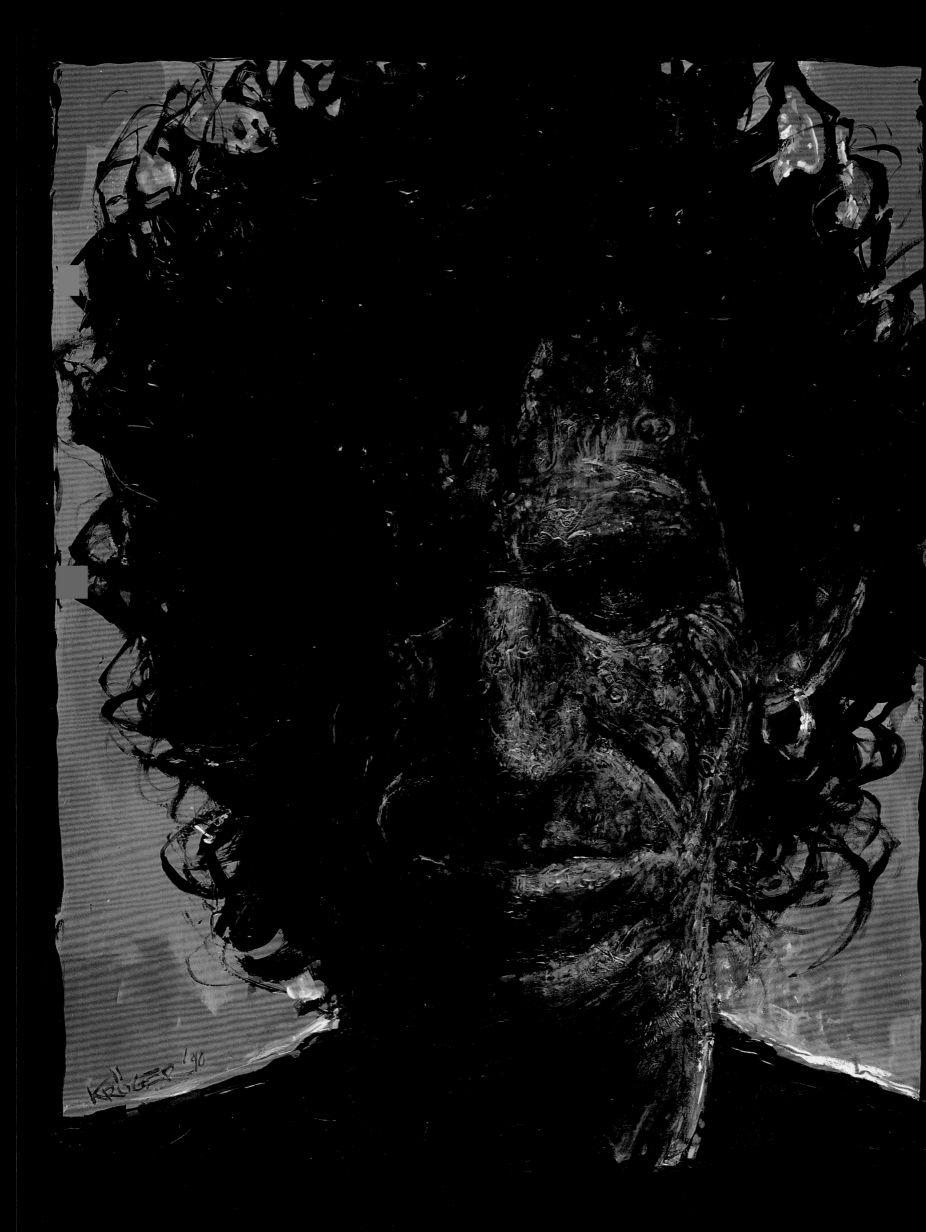

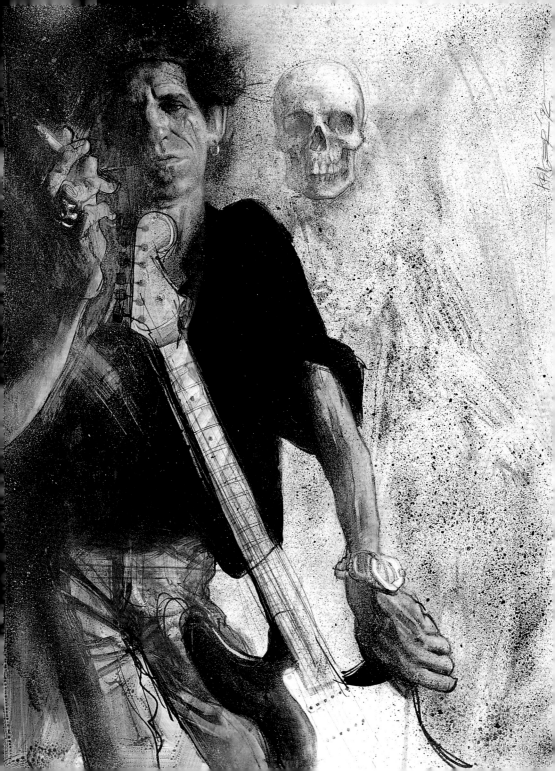

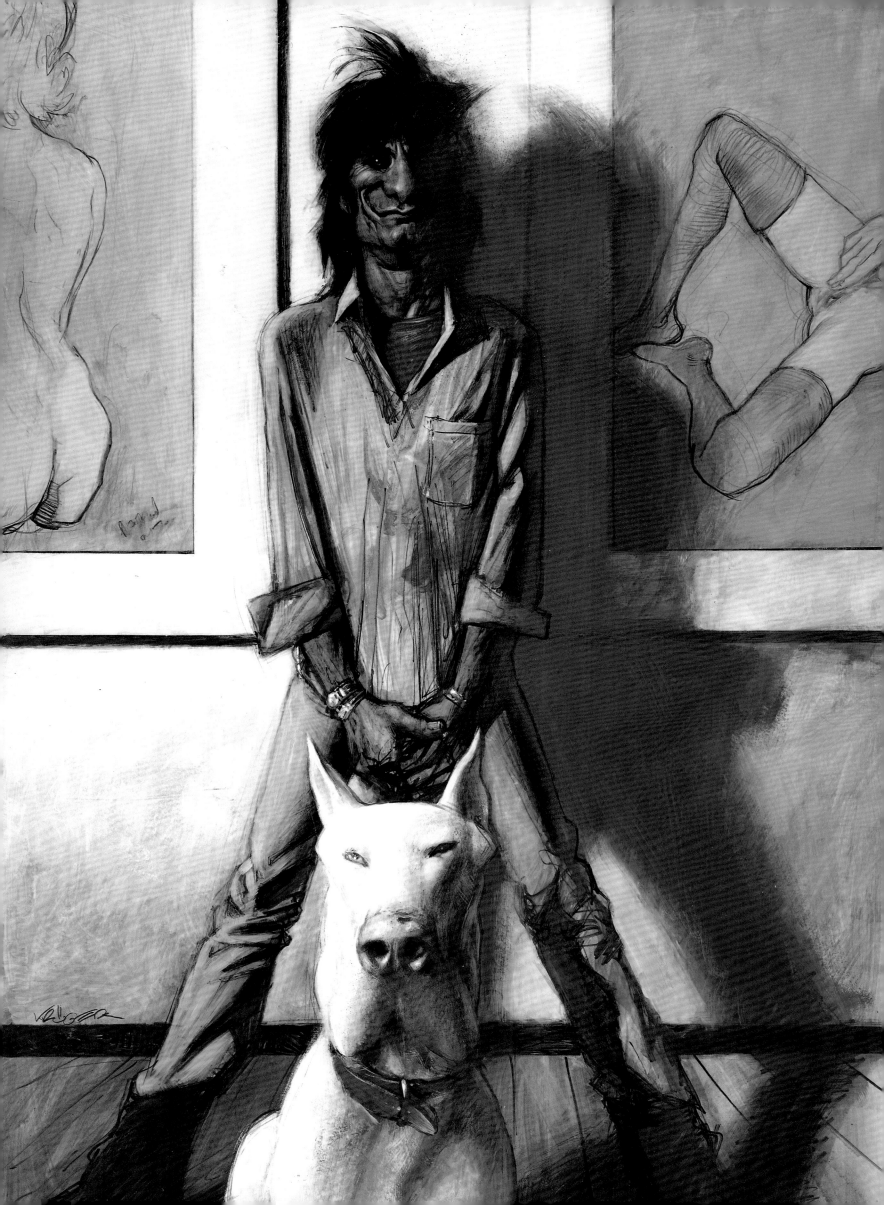

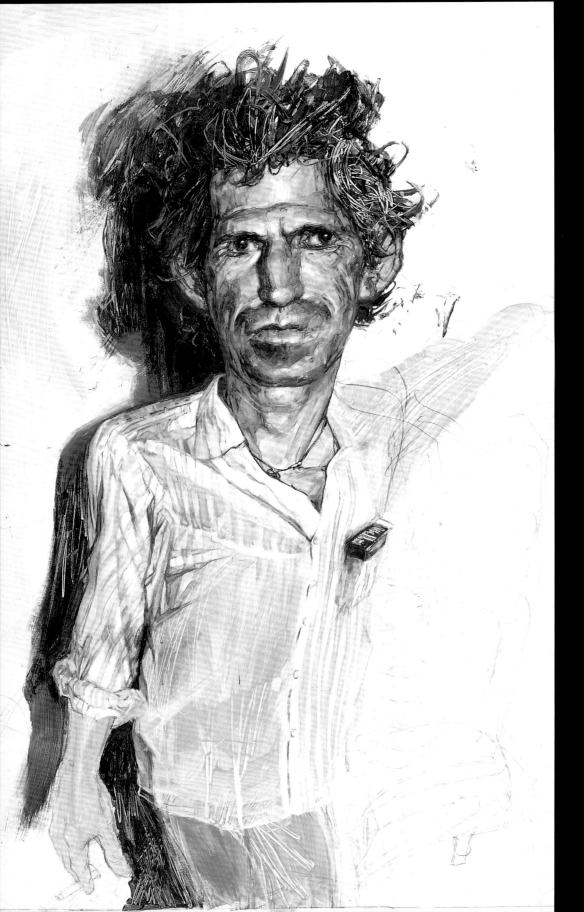

"When you look Keith in the eye, you know you're not going to bullshit him, and when you are going to bullshit him, do not look him in the eye. There's only one way he likes to say things, and that's brutally honest. He's not going to preach to you but he does have a moral code of honesty and loyalty and sincerity."
Steve Jordan

„Wenn man Keith in die Augen blickt, weiß man, daß man ihm nichts vormachen kann - aber wenn man die Absicht hat, ihn zu verscheißern, sollte man ihm nicht in die Augen blicken. Alles, was er zu sagen hat, sagt er mit brutaler Offenheit. Er hält keine langen Predigten, aber er lebt nach einem Ehrenkodex aus Ehrlichkeit, Loyalität und Anstand."
Steve Jordan

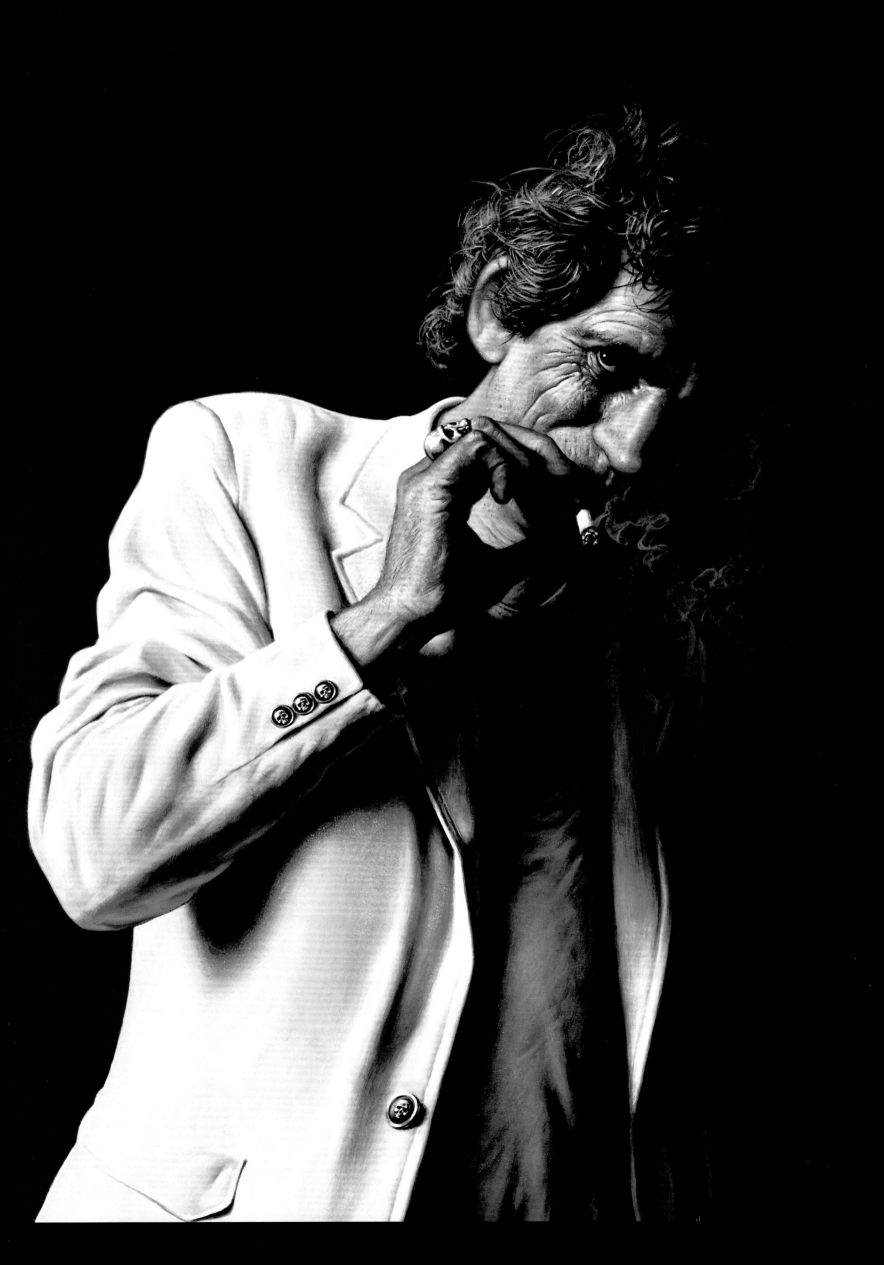

"When I first met Keith all I could think was: 'This is a guy who really needs a friend.' I gave him the keys to my apartment after only knowing him two weeks. There was no sexual thing going on. I knew he just needed a secret place where he could get far away from the madding crowd. It wasn't love at first sight, though it feels like that now. It just sort of mutually grew. But he is the most romantic man. So romantic. I have no regrets about my life with Keith. He's so good to me. I'm happy being a wife and a mother."

Patti Hansen

„Bei unserer ersten Begegnung dachte ich nur ‚Dieser Typ braucht unbedingt eine Freundin'. Schon zwei Wochen später gab ich ihm den Schlüssel zu meinem Appartment. Es ging uns gar nicht so sehr um Sex, er brauchte einen geheimen Ort, an den er sich vor der tobenden Menge in Sicherheit bringen konnte. Es war keine Liebe auf den ersten Blick, obwohl es jetzt vielleicht so aussieht. Wir sind uns nach und nach immer näher gekommen. Aber er ist der größte Romantiker, den ich kenne. Ich bereue es nicht, Keith geheiratet zu haben. Er ist so gut zu mir. Ich bin glücklich als Frau und Mutter."

Patti Hansen

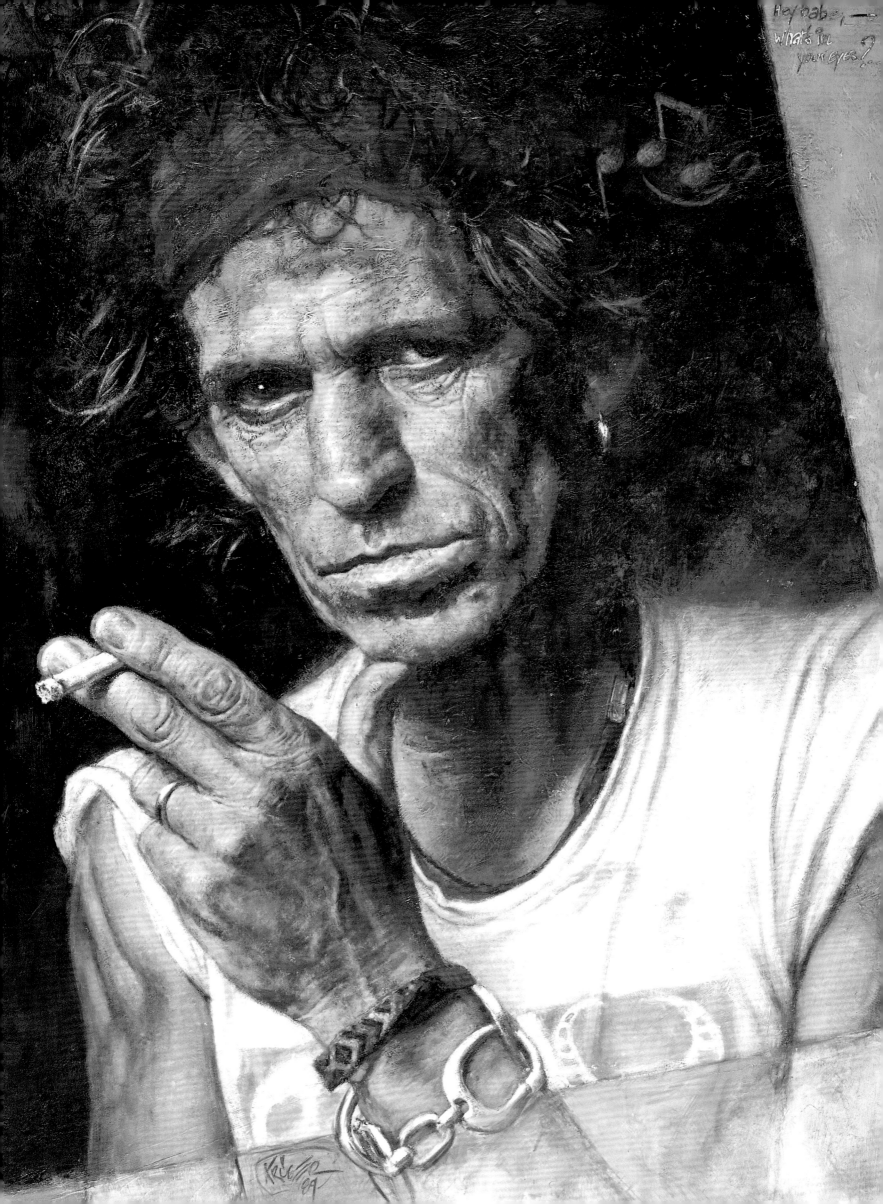

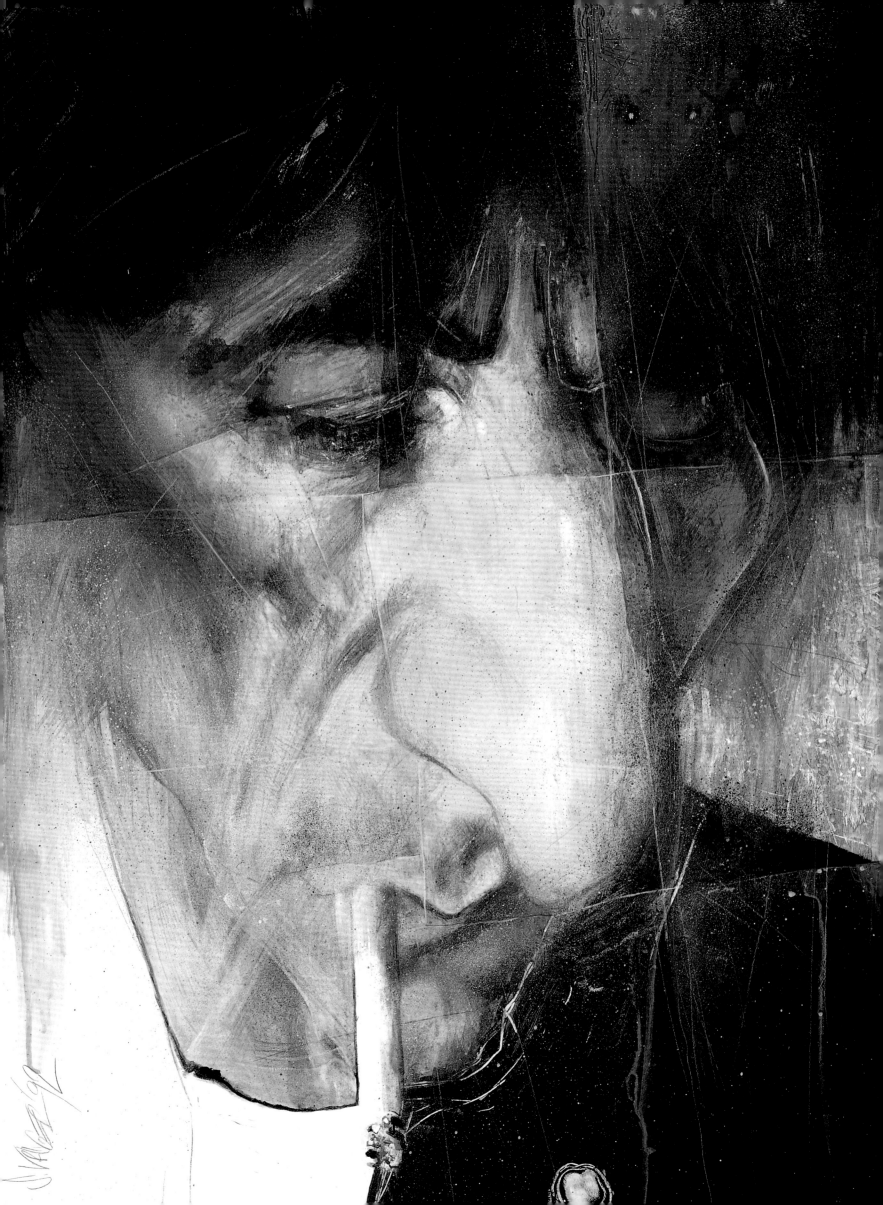

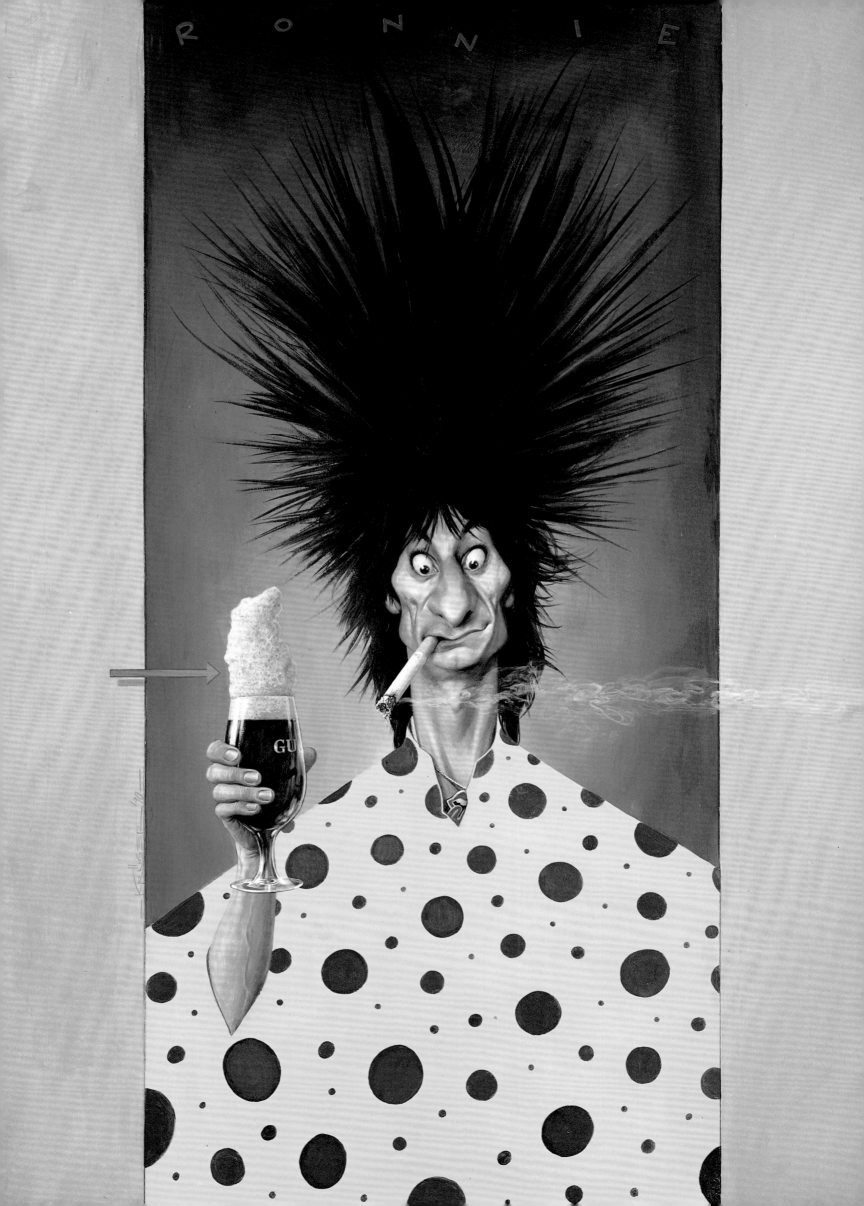

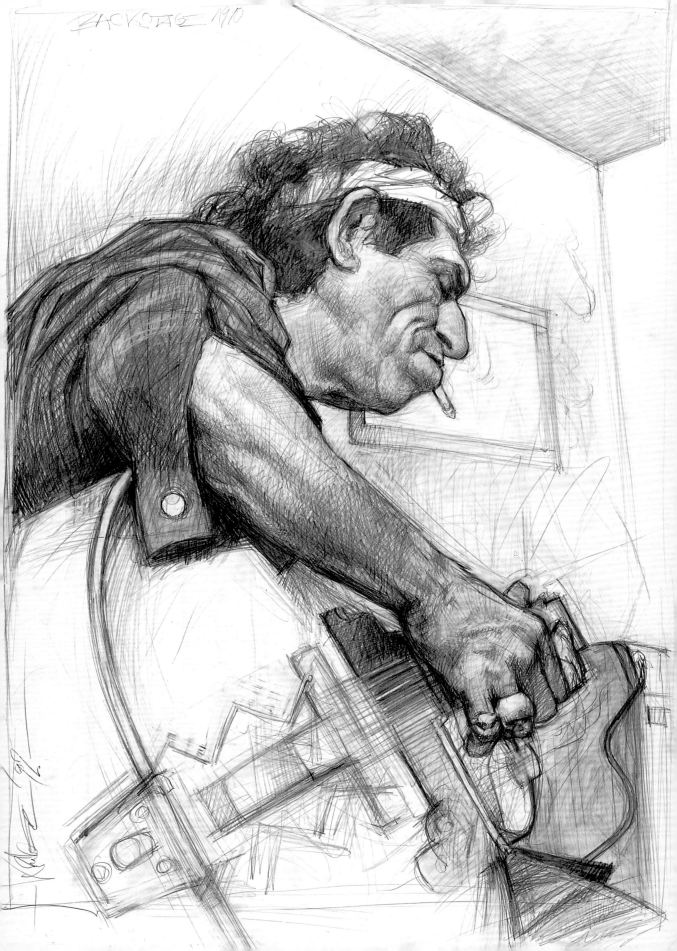

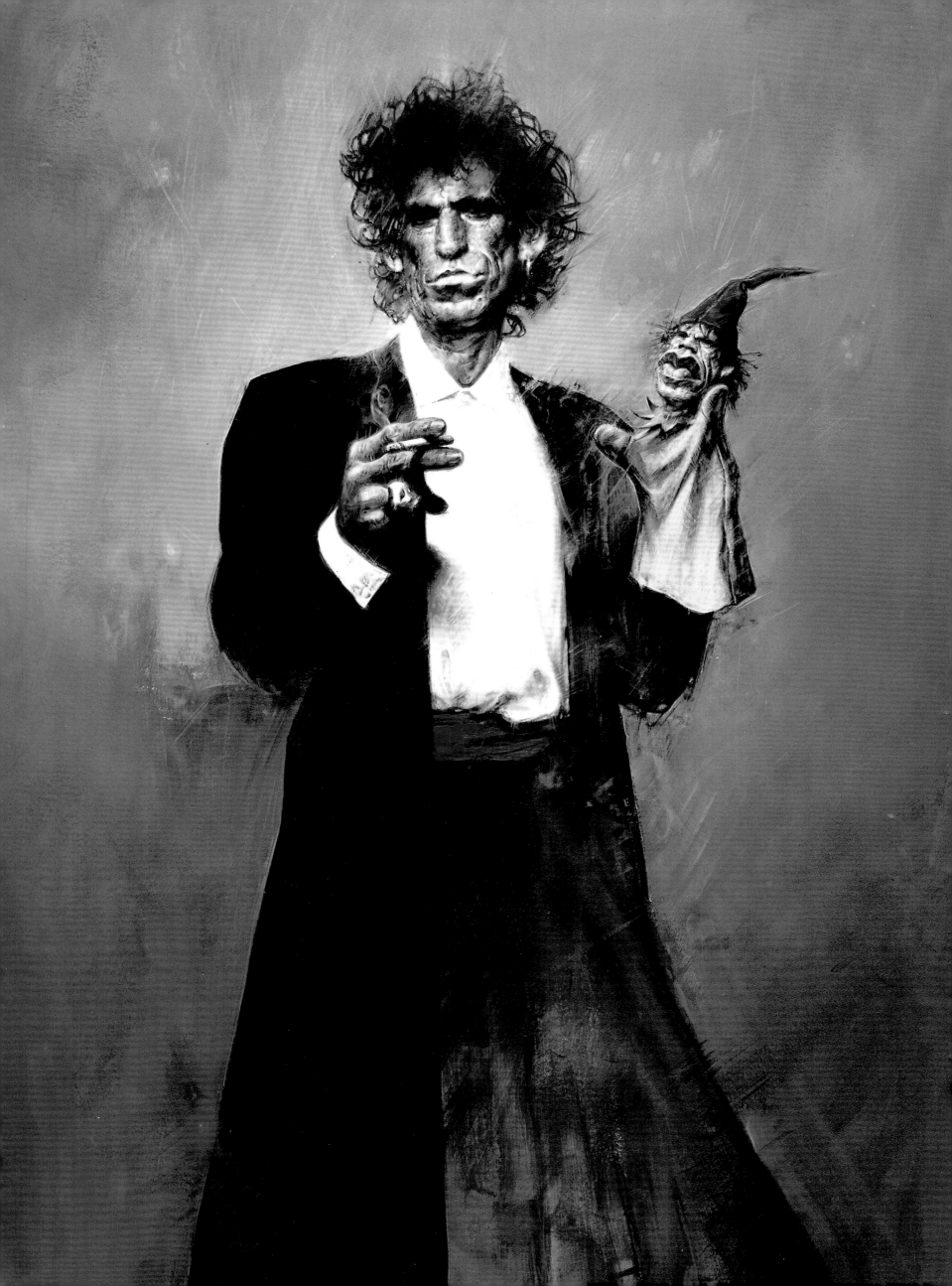

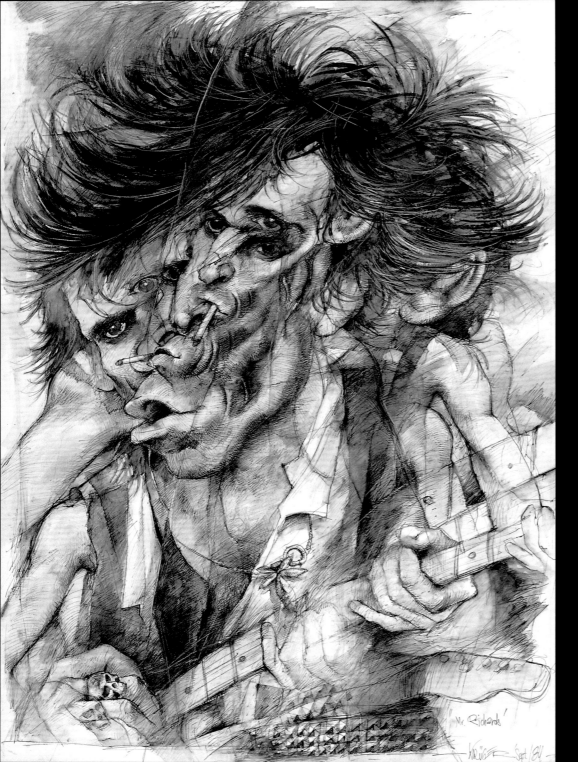

"Keith doesn't talk much. He prefers to play the guitar or piano or sing. That's his dialogue; rock and roll music is his language of love. I found Keith to be very much on the main road. He was still in love with the music. You can see that all his infamy and fortune didn't matter much to him. When he put on his guitar, lines disappeared from his face."

Bono Vox, U 2

„Keith macht nicht viele Worte. Er spielt viel lieber Gitarre oder sitzt am Klavier und singt. Das ist seine Art, sich auszudrücken; der Rock'n Roll ist seine Sprache der Liebe. Keith weiß genau, was er will. Er ist verliebt in die Musik, und Ruhm und Reichtum scheinen ihm gar nicht so wichtig zu sein. Als er seine Gitarre nahm, verschwanden sogar die Falten aus seinem Gesicht."

Bono Vox, U 2

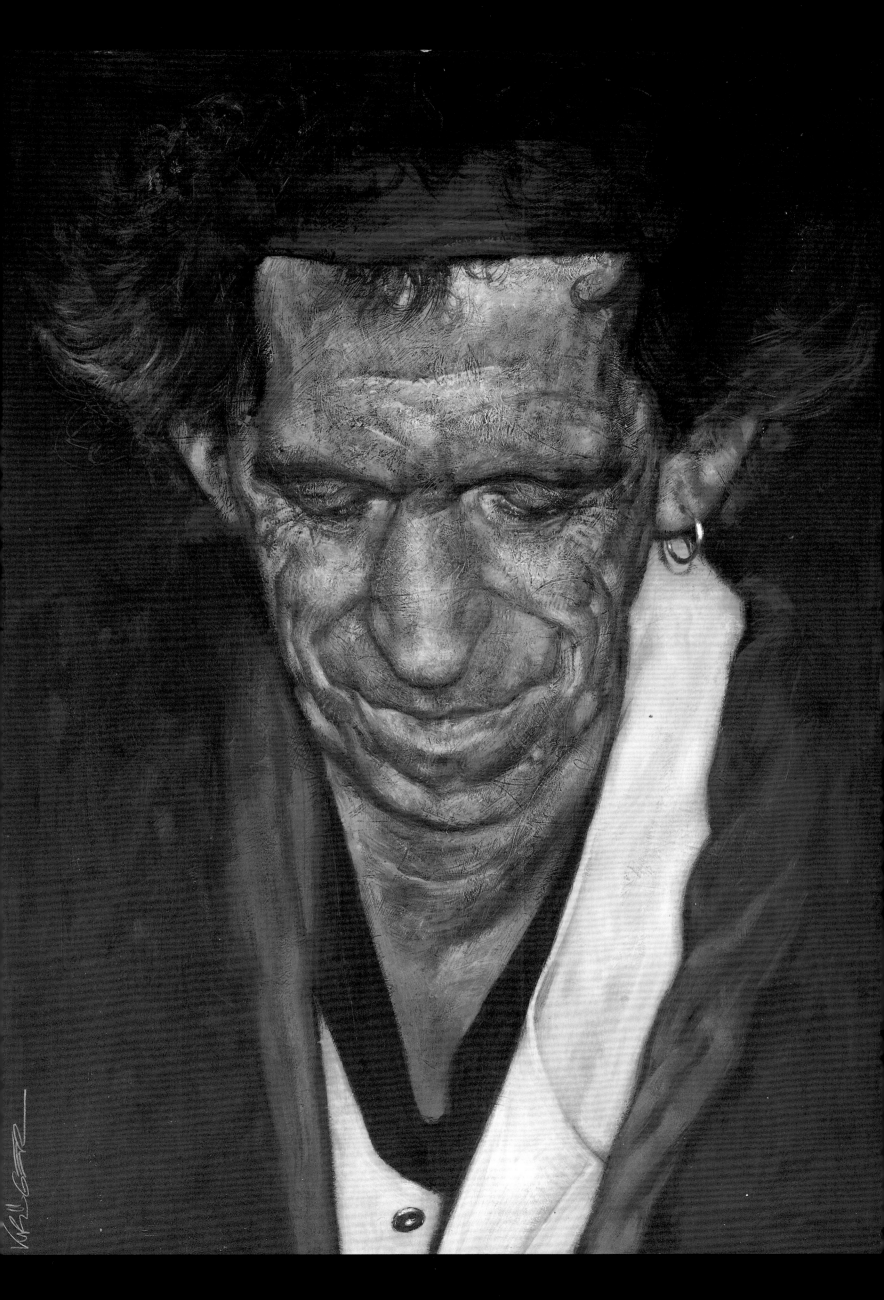

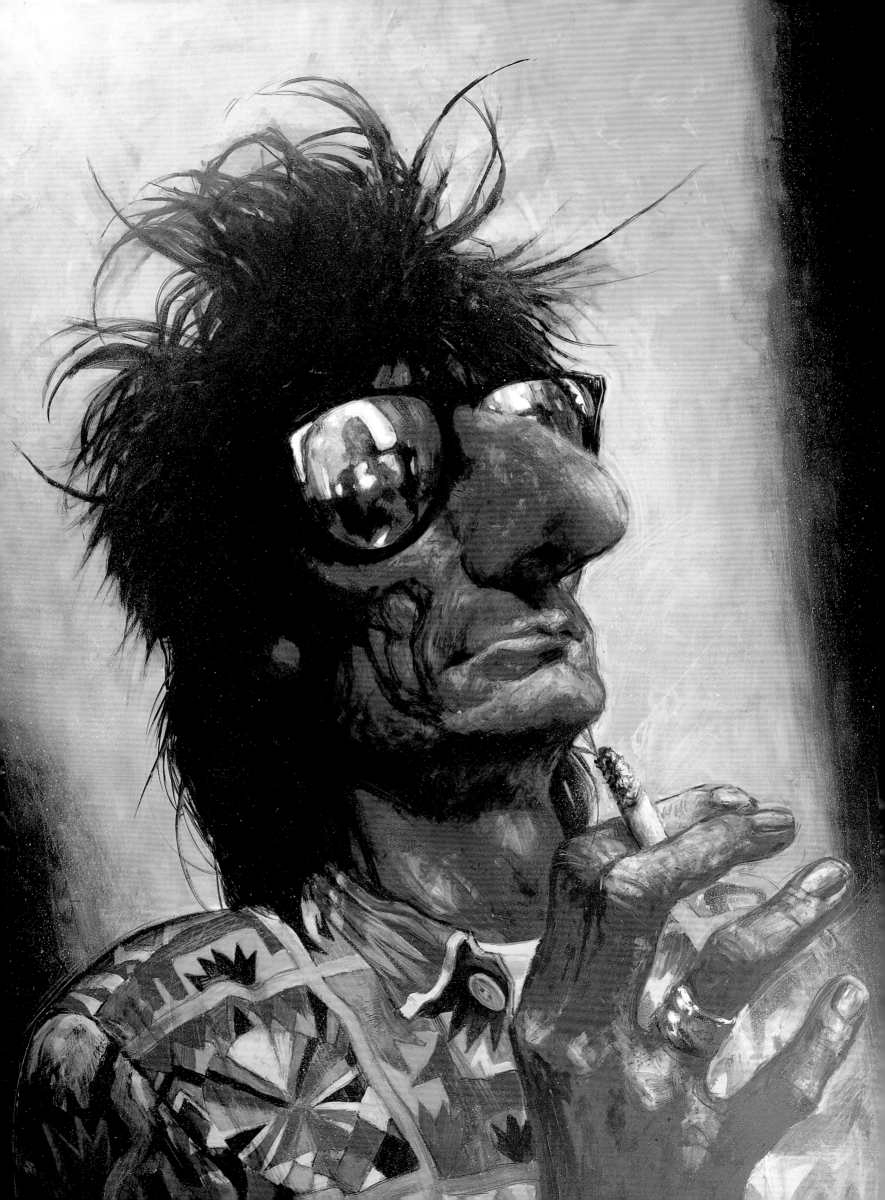

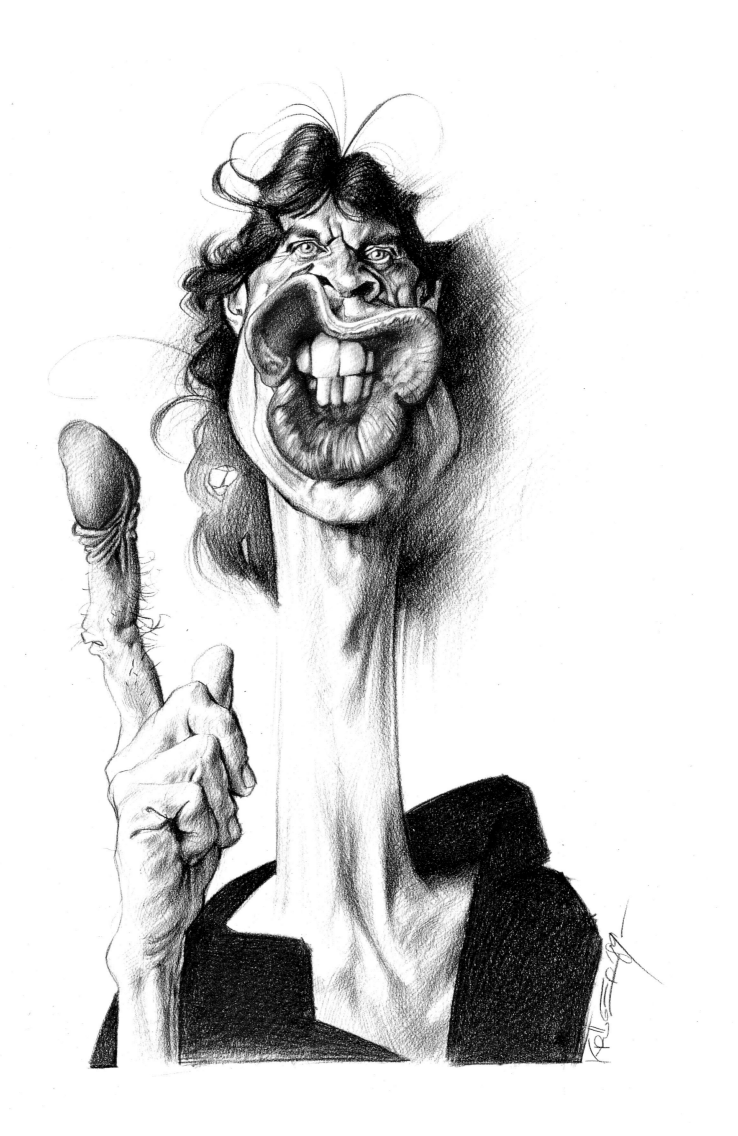

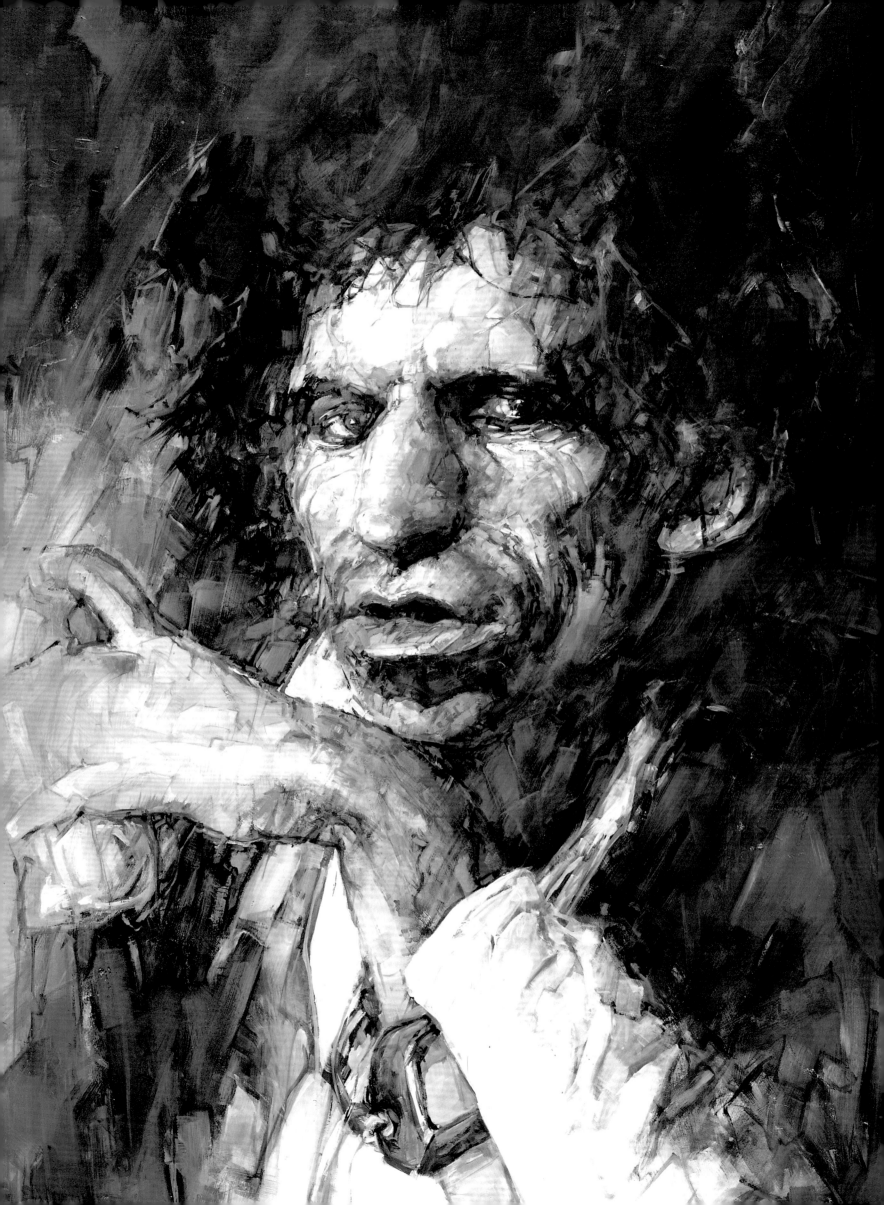

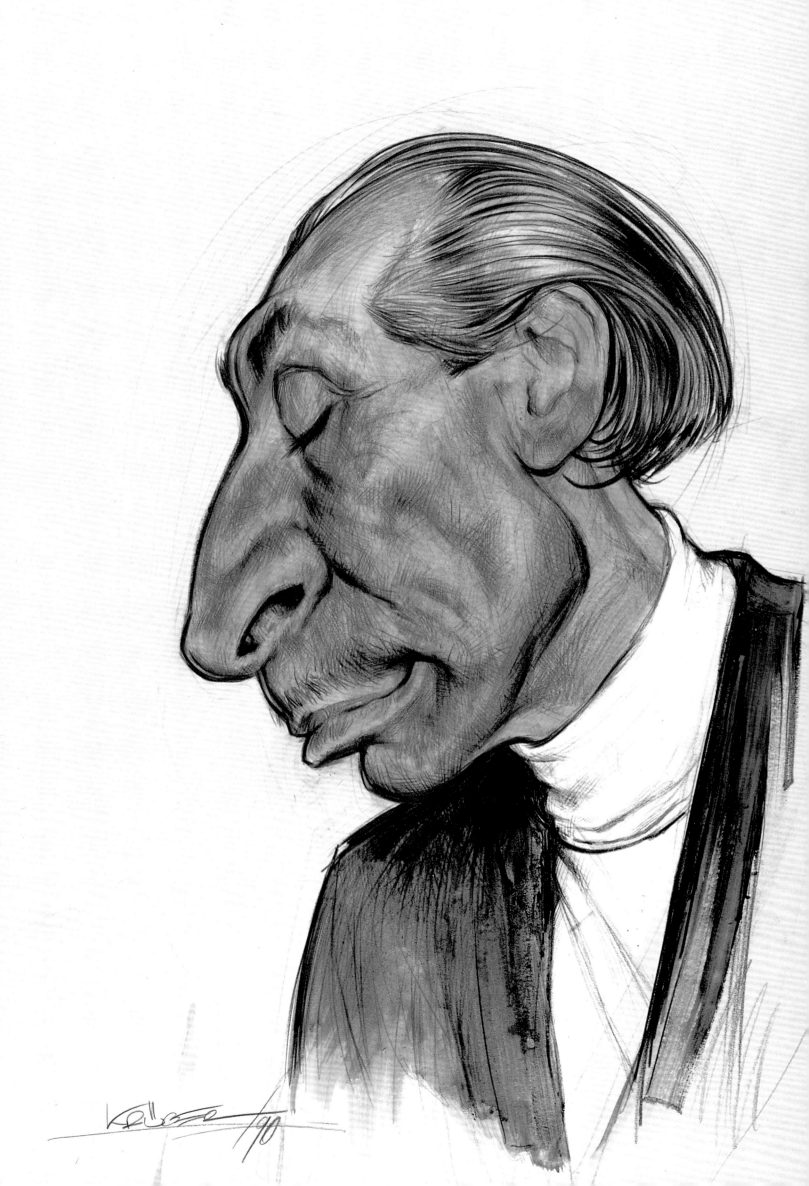

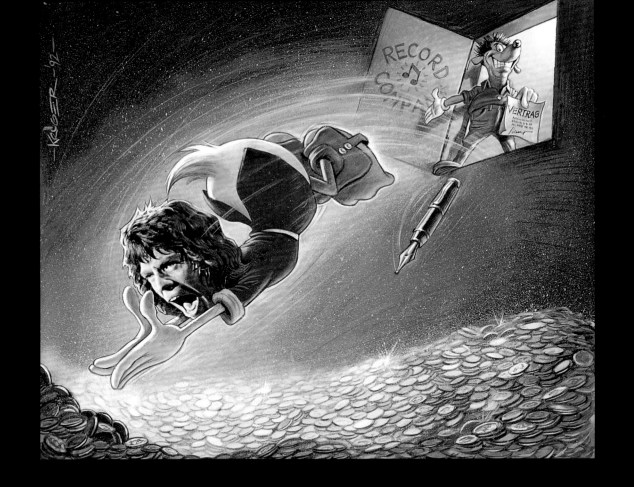

"Of Brian, Mick, and Keith, Keith was the most open. Brian was interested in portraying himself as any of the fantasies he had of himself. Mick was always very deliberate about the way he presented himself. Keith was the least interested in portraying himself as something other than he was. Keith is a man of belief and Mick is a man of fear. Mick works on fear, that driving thing, 'What if I fuck up?' It is a lot easier to be like Keith than it is to be like Mick." Alexis Korner

„Keith war von den dreien die ehrlichste Haut. Brian ging es darum, sich so darzustellen, wie er sich in seinen Phantasien sah. Mick war stets auf sein äußeres Erscheinungsbild bedacht. Keith hatte das geringste Interesse daran, sich irgendwie zu verstellen. Er war von sich überzeugt, dagegen hegte Mick Selbstzweifel. Mick braucht die Angst und die Ungewißheit, aus ihnen schöpft er seine Kraft. ‚Was ist, wenn ich versage?' Es ist viel leichter, so wie Keith zu sein als so wie Mick."
 Alexis Korner

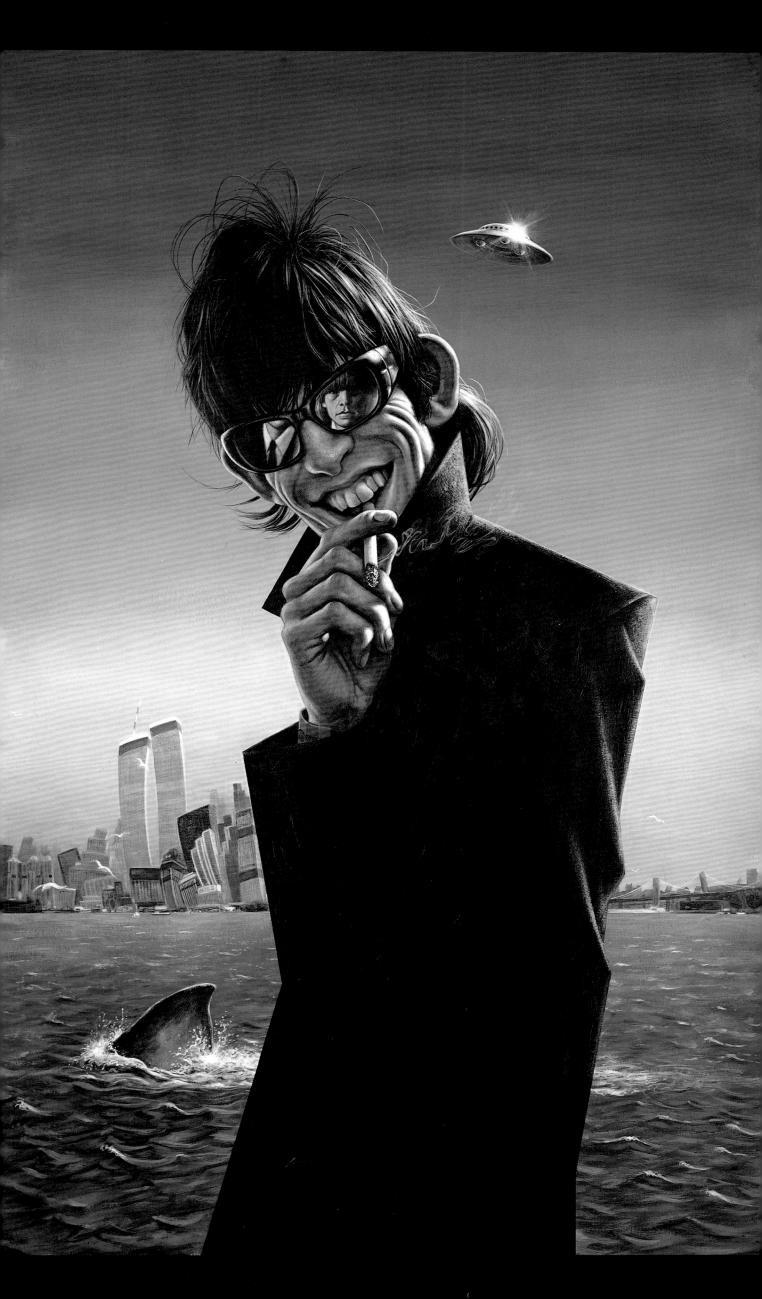

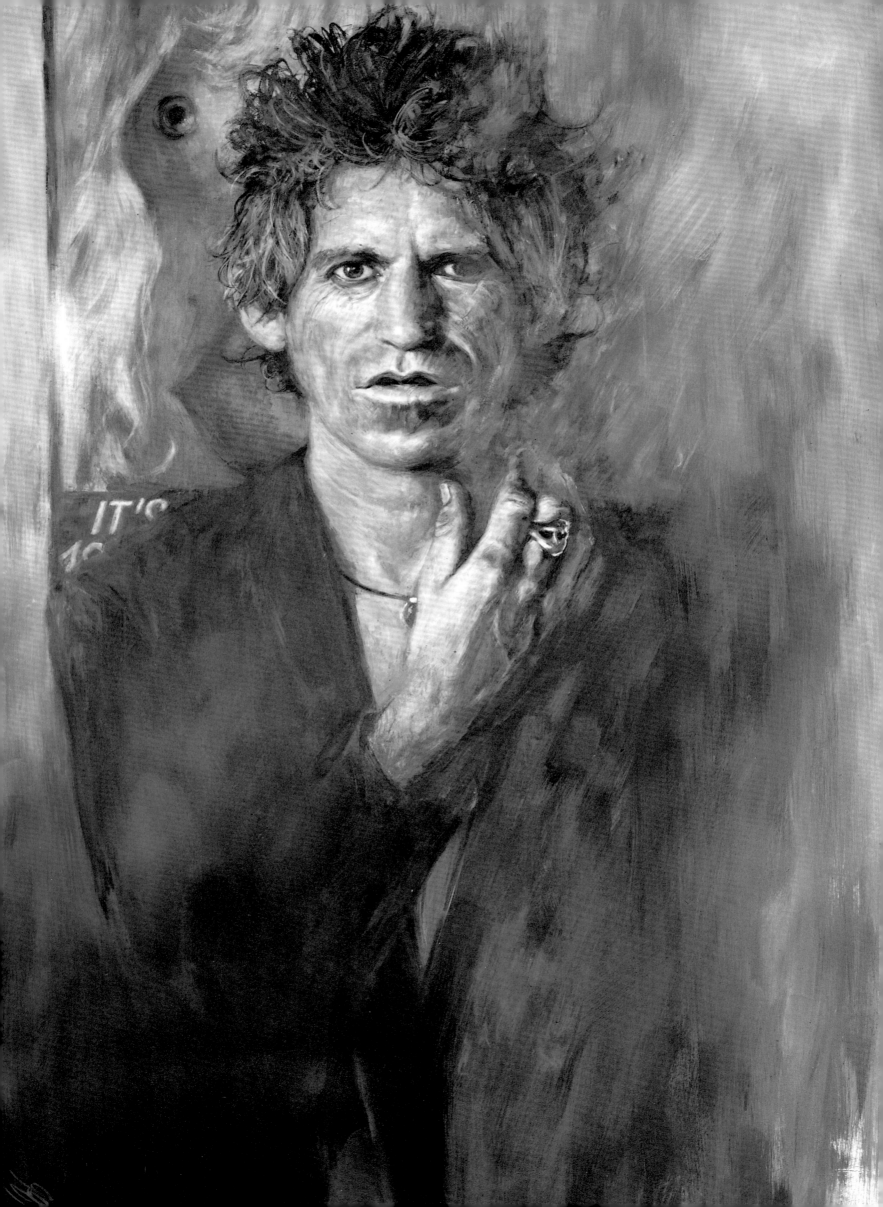

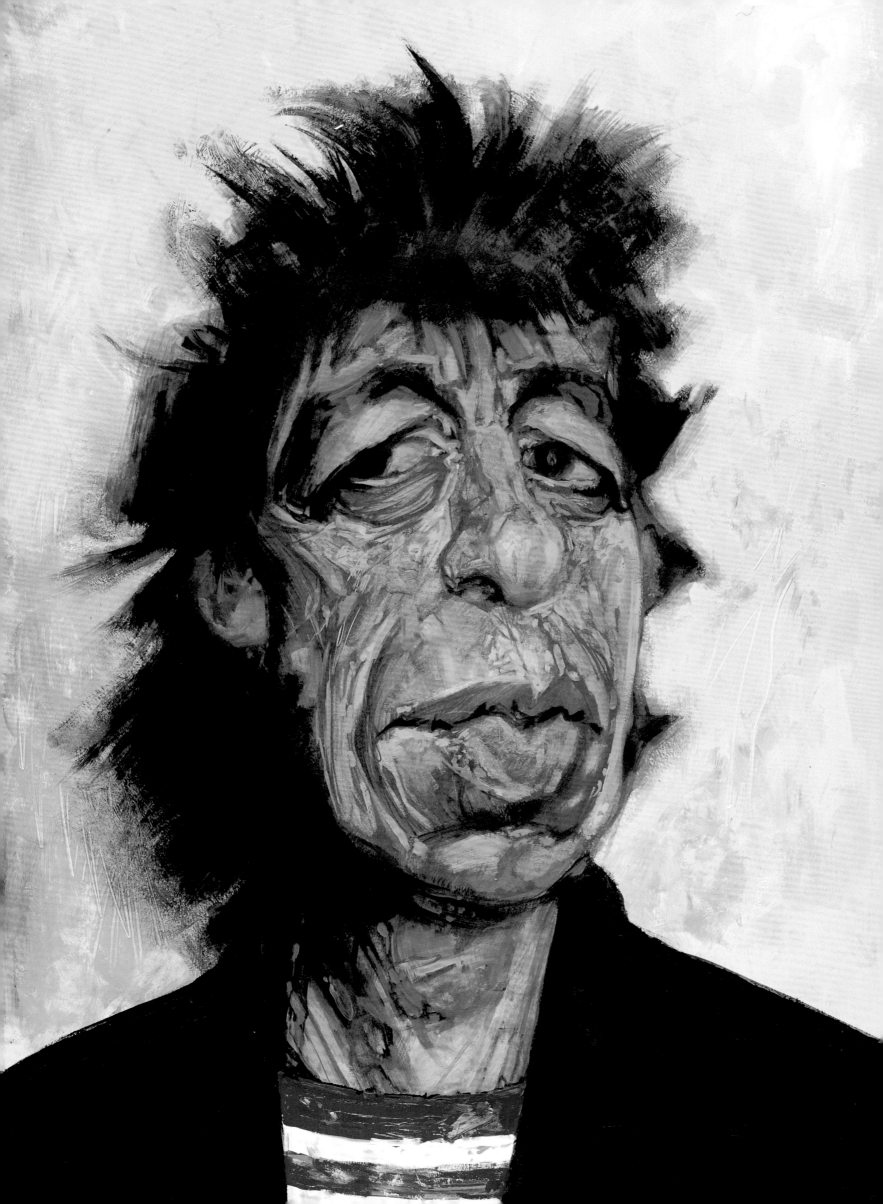

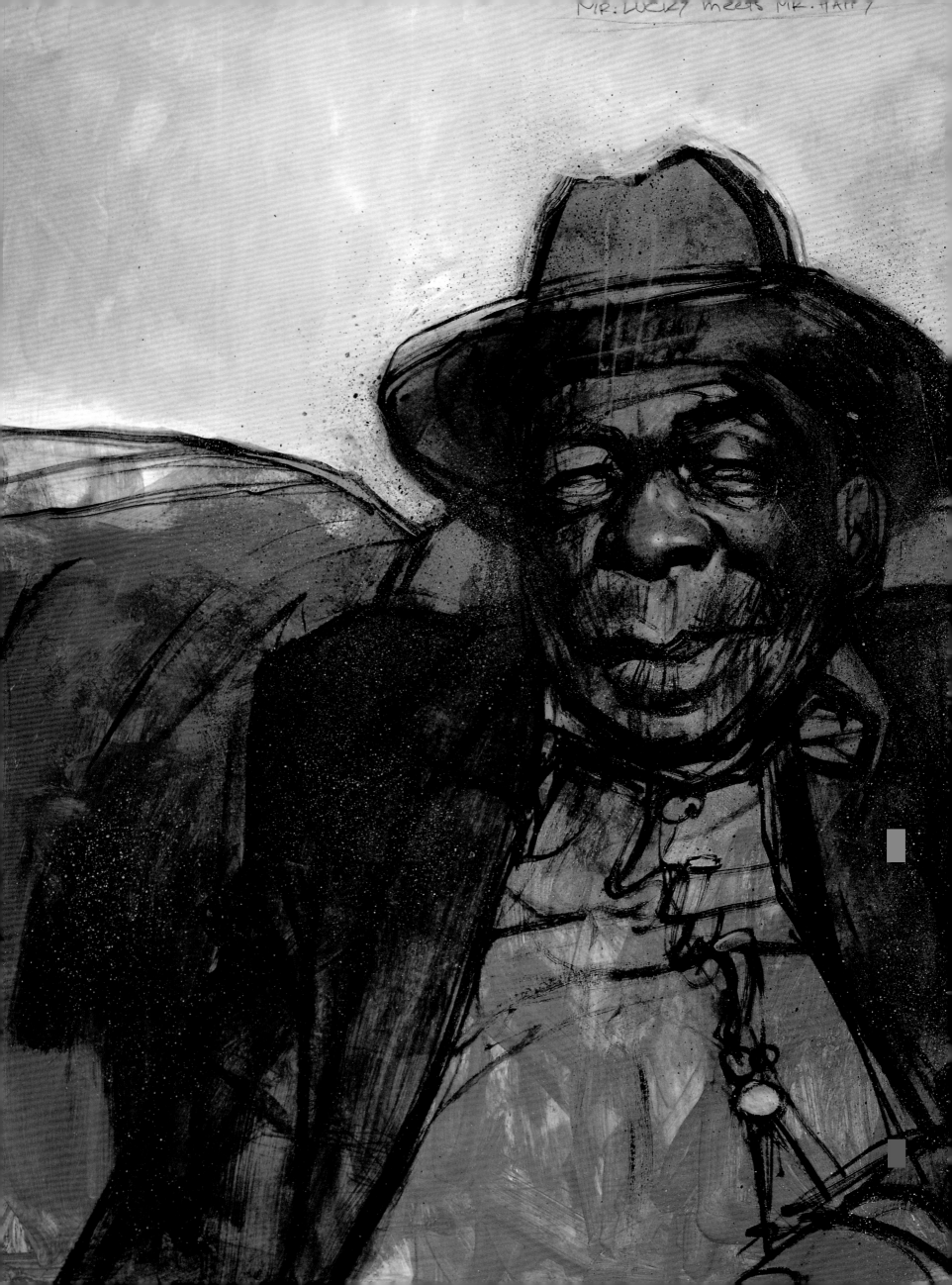

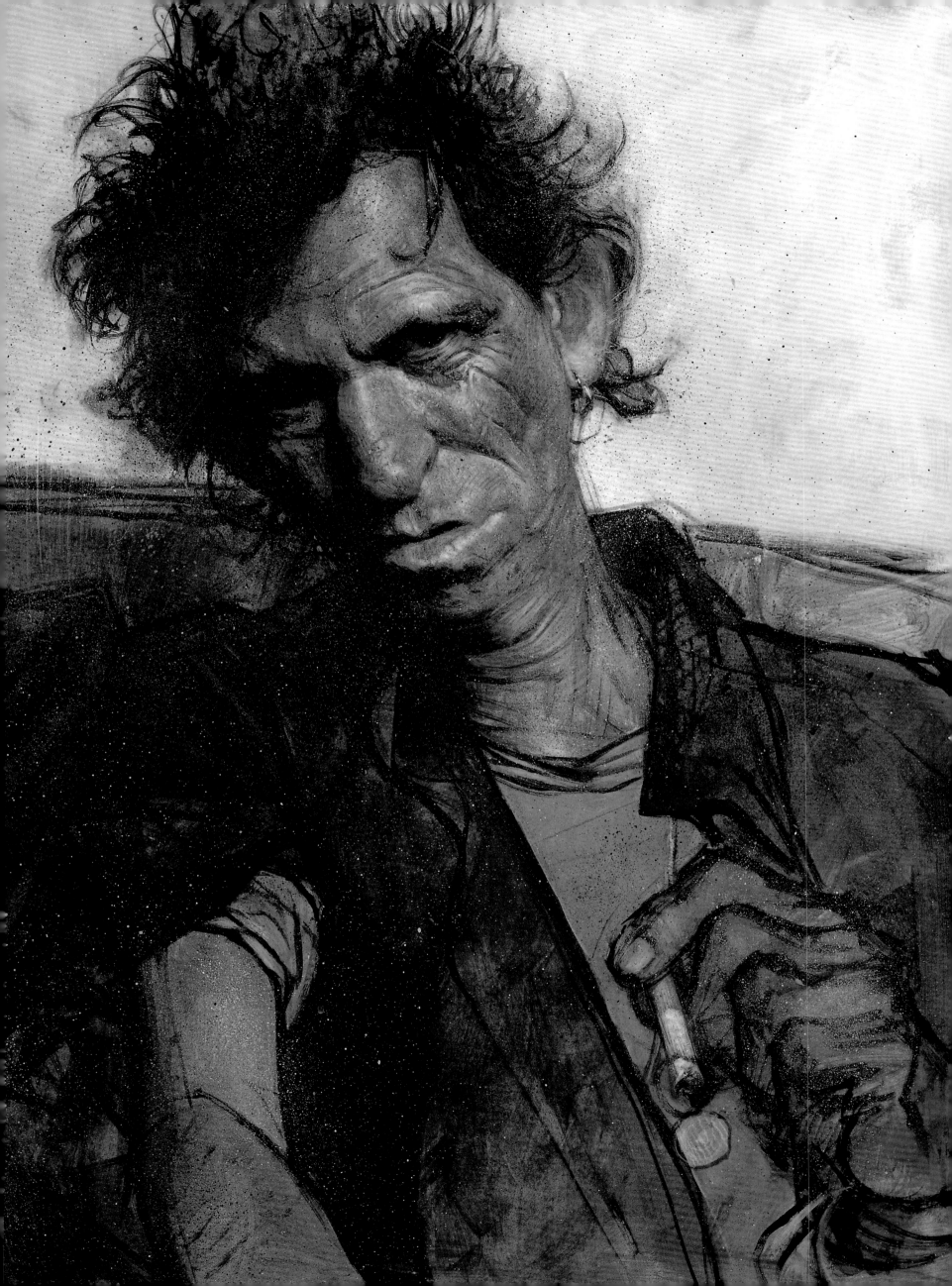

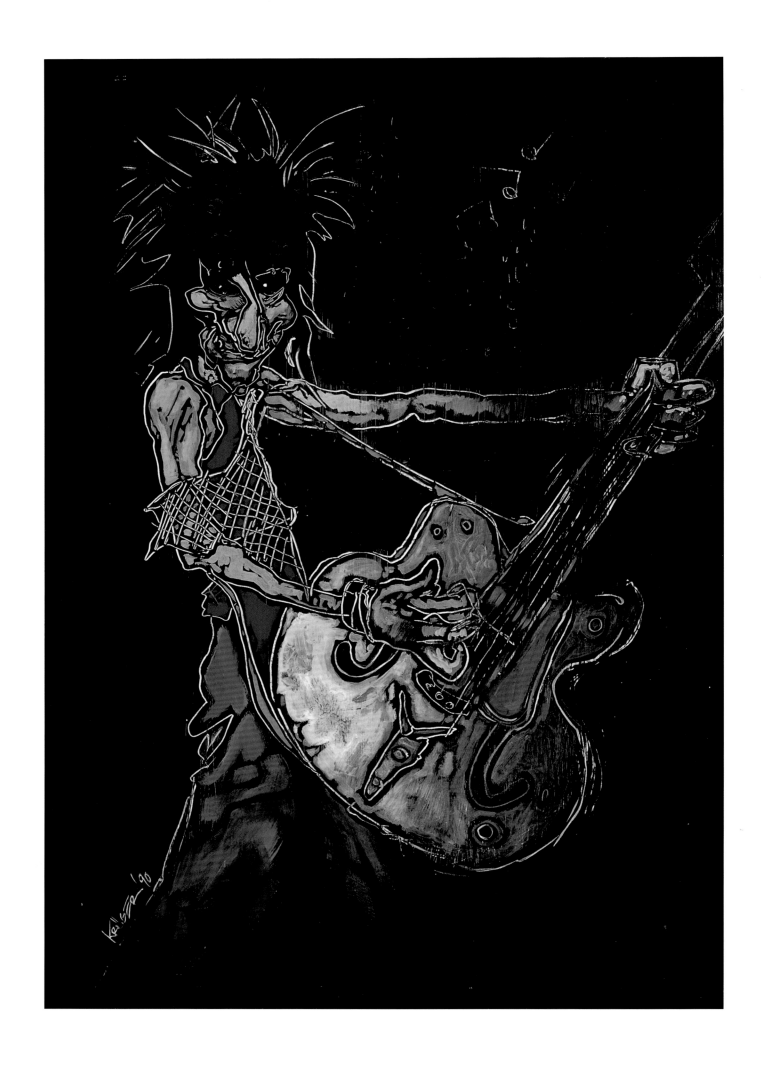

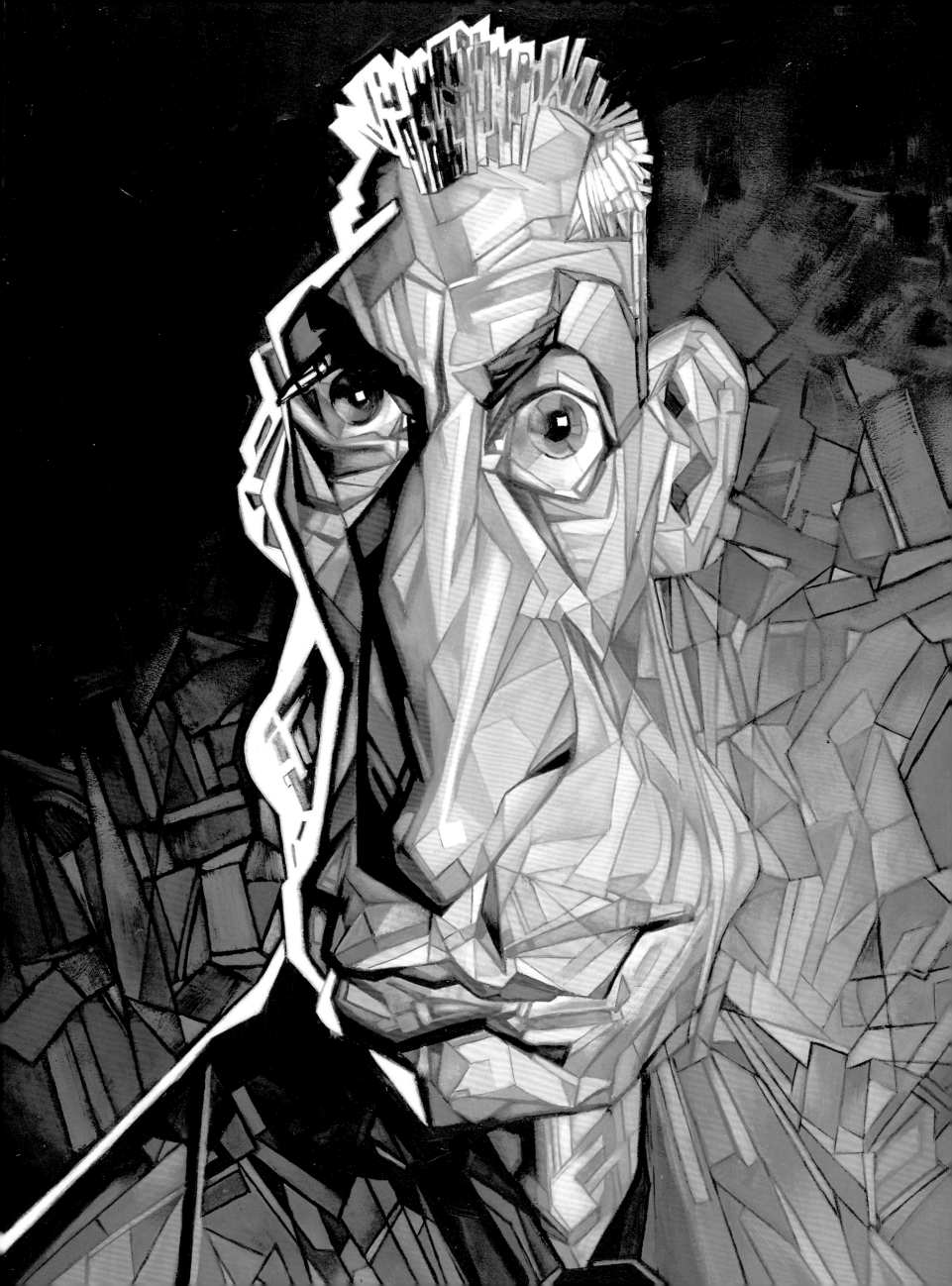

STEEL WHEELS

No.7

December 1991

The Rolling Stones Fan Club Magazine

5.–DM/Members free

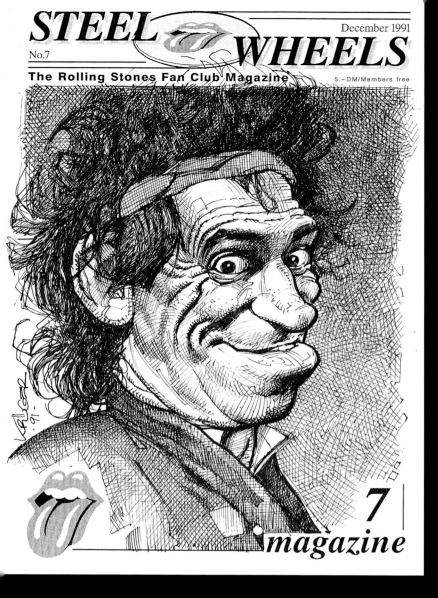

7

magazine

STEEL WHEELS

No.7

December 1991

The Rolling Stones Fan Club Magazine

5.–DM/Members free

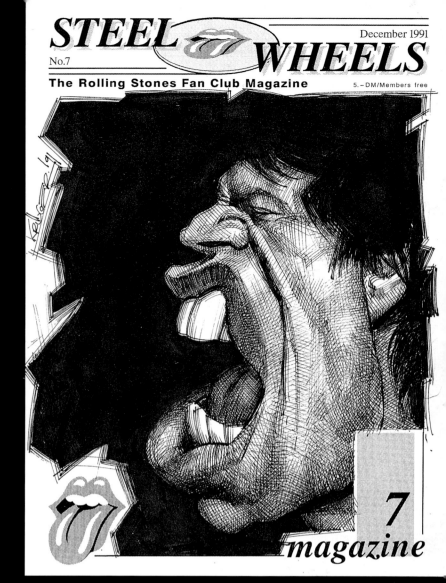

7

magazine

"We needed to clear the air, which, as old mates, we're very good at. Then, when we got into that room and sat down with our guitars, something entirely different took over. You can define it, it's the same thing that always happens. I just start banging out a little riff. He'll go, 'That's nice', and he'll come up with a top line. The good thing is that once Mick and I actually settle down in a room to work, everything else goes out the window."

Keith Richards

"We weren't great friends, but we knew each other. He used to dress in a cowboy outfit, with holsters and a hat, and he had these big ears that stuck out. I distinctly remember this conversation I had with Keith. I asked him what he wanted to do when he grew up. He said he wanted to be like Roy Rogers and play guitar."

Mick Jagger

„Wir mußten mal wieder so richtig Dampf ablassen, und als alte Freunde haben wir ja darin reichlich Erfahrung. Aber als wir uns dann mit unsern Gitarren hingesetzt haben, herrschte mit einem Mal eine ganz andere Stimmung. Man kann das nicht beschreiben, aber es passiert immer wieder. Ich fang an, irgendwas zu spielen. 'Nicht schlecht', meint er und

entwickelt daraus eine Melodie. Das ist das Tolle - wenn wir so zusammensitzen und arbeiten, vergessen wir alles andere um uns herum."

Keith Richards

„Wir waren keine dicken Freunde, aber wir kannten uns eben. Er lief in Cowboy-Klamotten durch die Gegend, mit Halfter und Hut, und er hatte diese riesigen, abstehenden Ohren. Ich erinnere mich noch ganz genau an ein Gespräch mit Keith. Ich fragte ihn, was er mal machen will, wenn er groß ist. Er sagte, er wolle so werden wie Roy Rogers und Gitarre spielen."

Mick Jagger

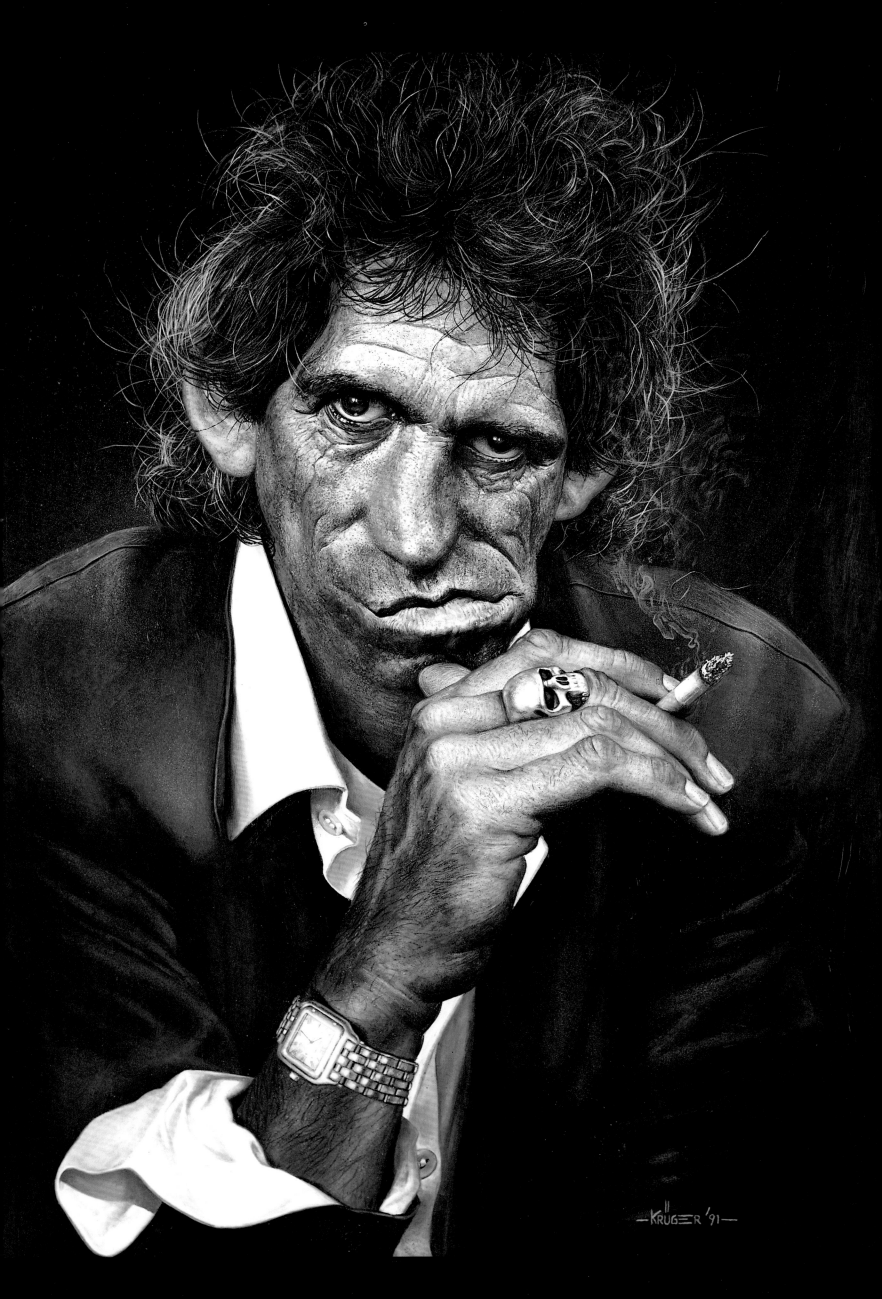

-KRUGER '91-

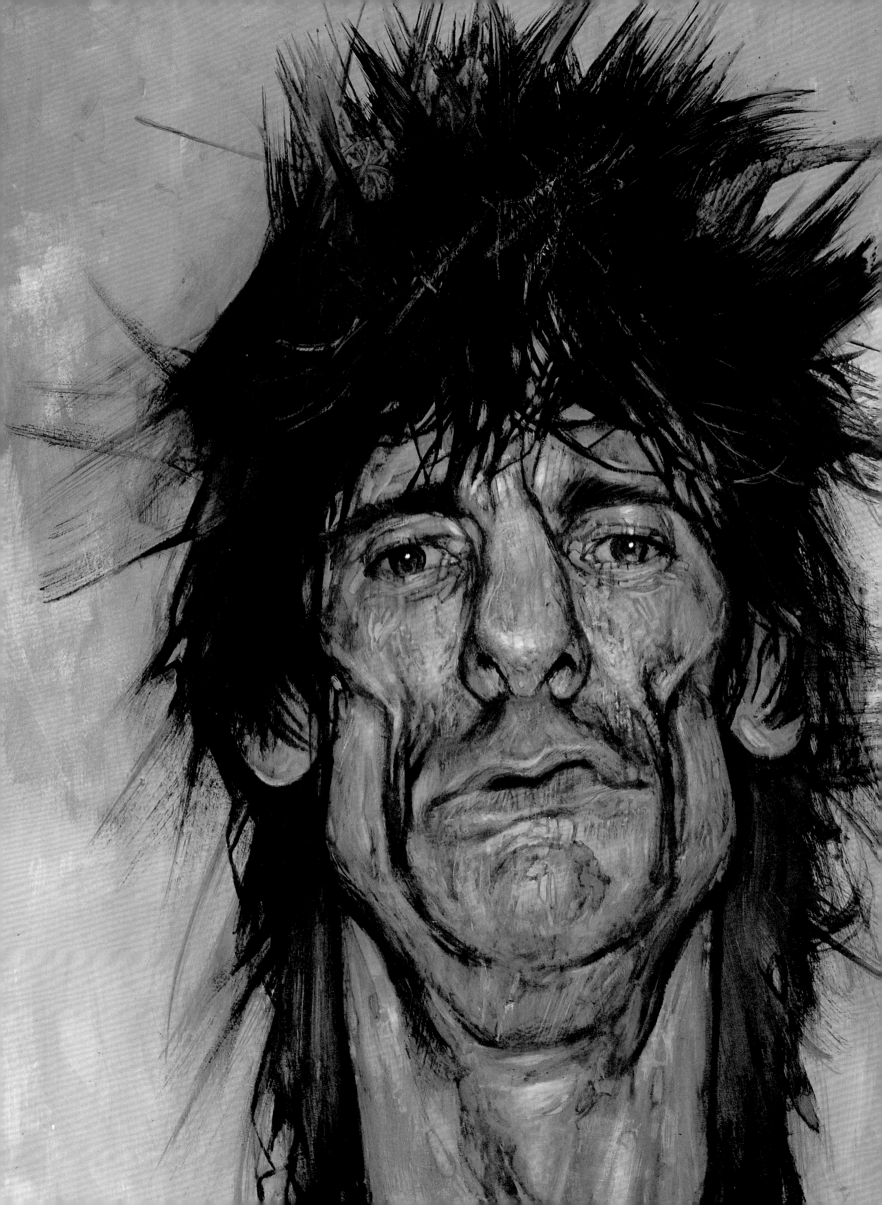

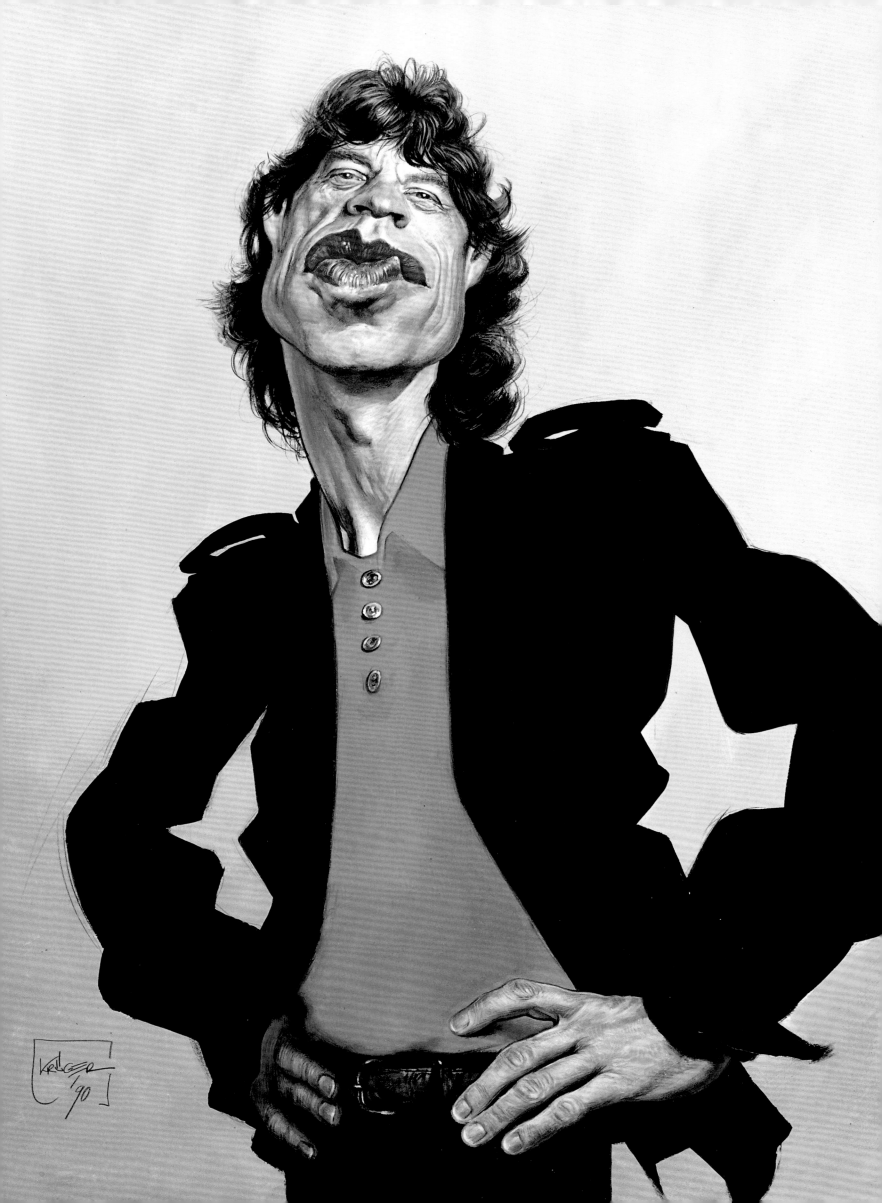

"Keith marched into the Rocke-
feller Center offices of Rolling
Stones Records at 6 p.m., loudly
announcing, 'I'm ready for my
bacon and eggs'. He was waving
a fifth of Jack Daniel's. He had
just awoken and wanted break-
fast - the sour-mash bourbon
kind. He tried to crack the seal
on the Black Jack bottle, without
success. 'I've got a key we could
try', I ventured, but Keith cut me
off by whipping out this enor-
mous gravity knife and - kachunk!
- snapping it open. He winked at
me and held up the knife: 'This is
the key to the highway!' "

Chet Flippo

"He's such a strong personality,
a completely intuitive musician.
He moves like an animal. He's just
pure theater standing in the
middle of a room und putting on
his guitar and turning on his amp.
All this stuff is irregular. He's a kil-
ler, man. A great spirit. Like a
pirate, and he's a complete gen-
tleman."

Tom Waits

„Gegen 18 Uhr kam Keith in die
Stones-Büroräume im Rockefeller
Center hereinmarschiert und ver-
kündete lauthals ‚Ich brauche
jetzt meine Eier mit Speck'.
In der Hand hielt er eine Flasche
Jack Daniel's. Er war gerade auf-
gewacht und wollte frühstücken -
seine übliche Bourbon-Ration.
Er versuchte, die Flasche zu
öffnen - ohne Erfolg. ‚Wir könn-
ten es mit meinem Schlüssel
probieren', bemerkte ich zaghaft',
aber Keith zückte statt dessen
sein gewaltiges Klappmesser und
ließ es blitzend aufspringen. Er

blinzelte mir zu und hielt das
Messer in die Höhe: ‚Das hier ist
der Schlüssel zum Highway!' "

Chet Flippo

„Keith besitzt eine unglaublich
starke Persönlichkeit und läßt
sich als Musiker ausschließlich
von seiner Intuition leiten. Er
bewegt sich wie ein wildes Tier.
Er macht reines Rocktheater,
wenn er mitten im Raum steht,
seine Gitarre nimmt und den
Verstärker einschaltet. All das ist
einzigartig. Er ist ein Killer, Mann.
Ein Genie. Wie ein Pirat, aber
gleichzeitig ein perfekter
Gentleman."

Tom Waits

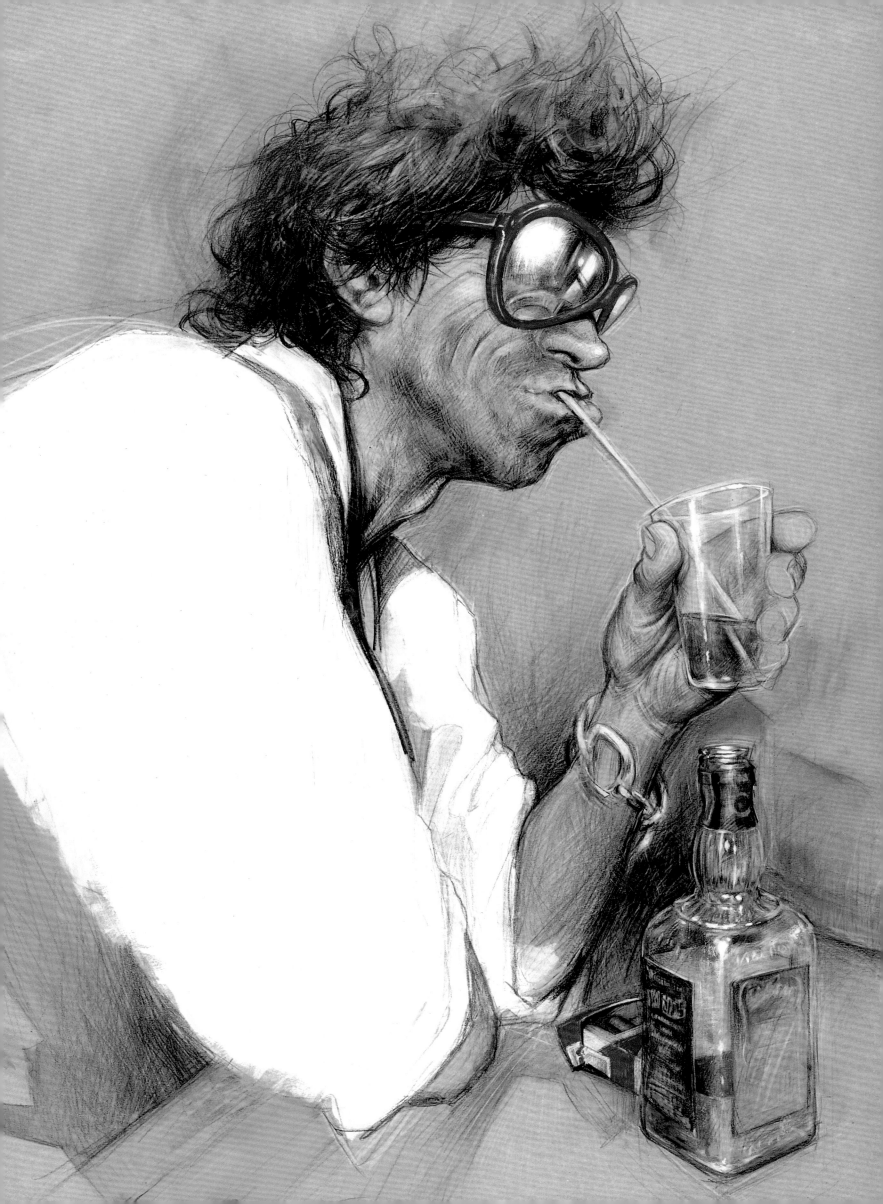

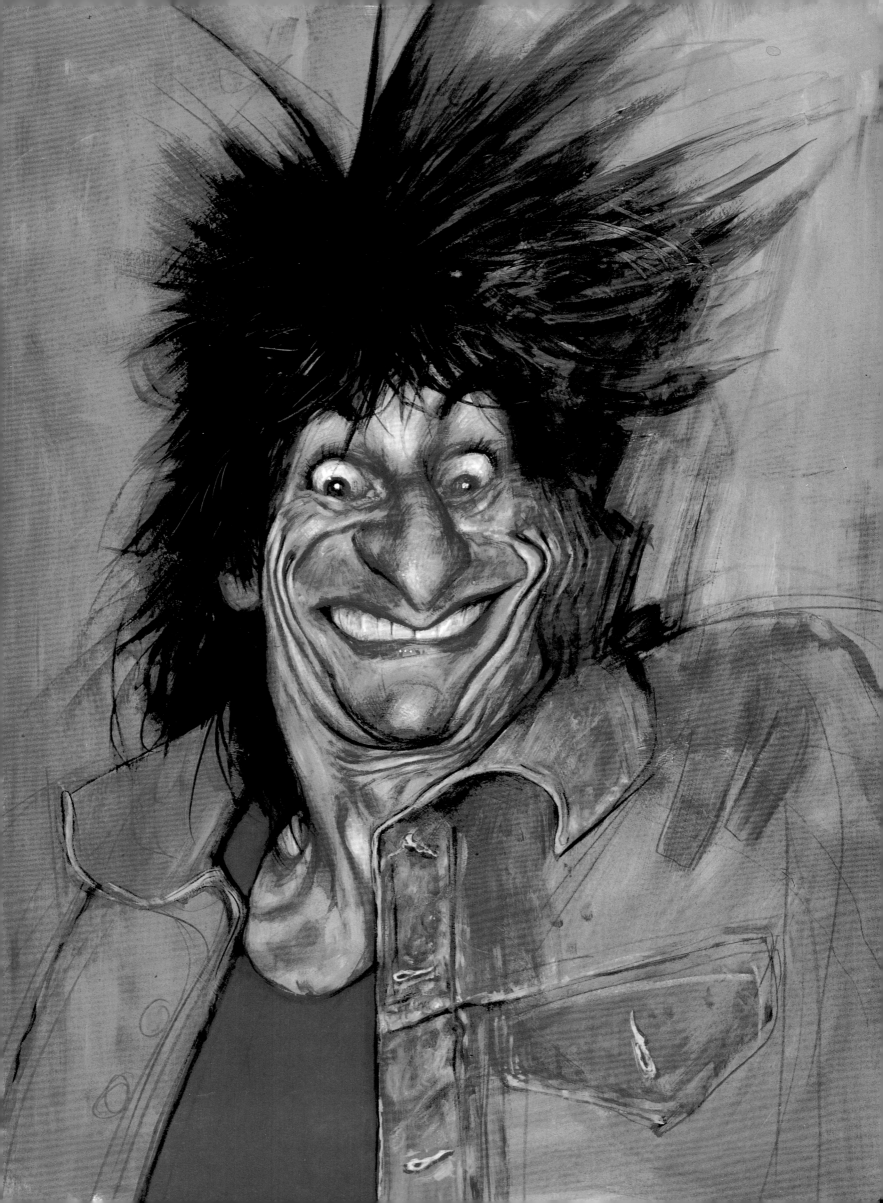

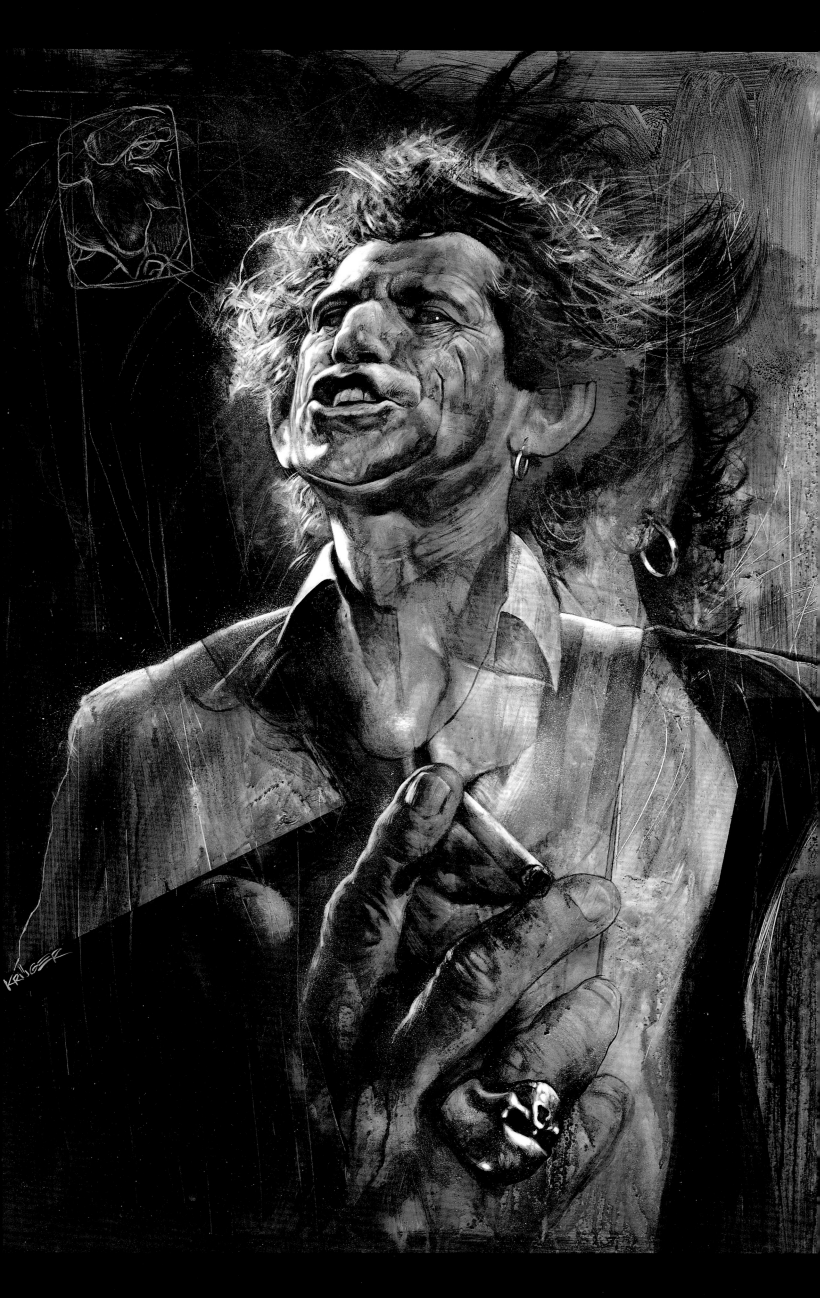

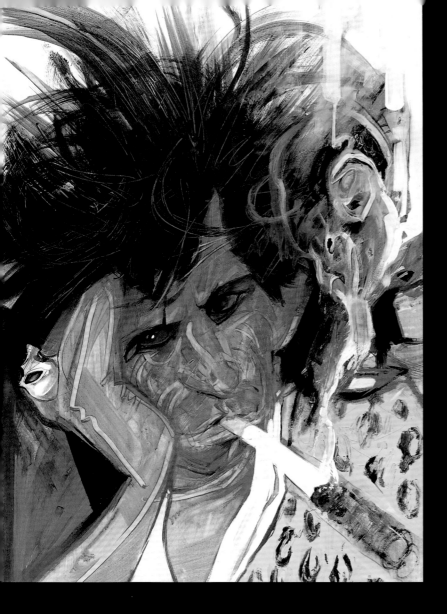

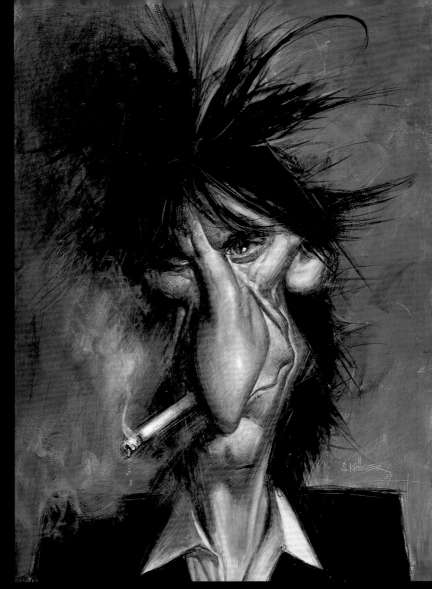

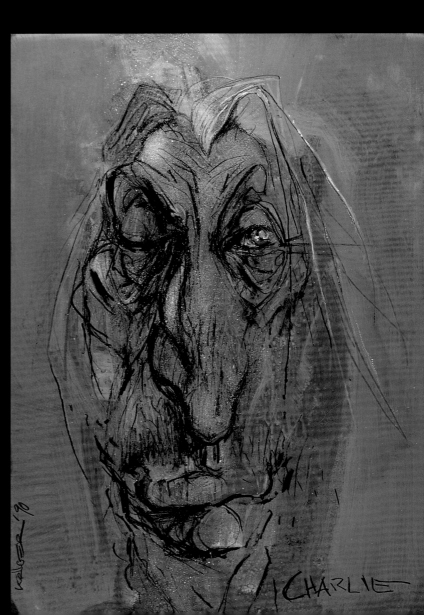

"Being a drummer with the Rolling Stones is much more creative than people think. Keith writes a song, then I can turn it into a samba or a waltz or anything. And if he likes it then that's fine. But in some other types of music, if a song is a waltz then you can't do anything about it. The dots are there on paper and you just have to play it as it's written."

Charlie Watts

„Schlagzeuger bei den Stones zu sein ist weitaus kreativer, als manche Leute denken. Keith schreibt einen Song, und ich kann daraus 'nen Samba, Walzer oder sonstwas machen. Und wenn's ihm gefällt - um so besser. Aber in anderen Bereichen der Musik geht das nicht. Wenn ein Stück als Walzer komponiert worden ist, kann man nichts dagegen machen. Die Noten stehen auf dem Papier, und danach hat man sich zu richten."

Charlie Watts

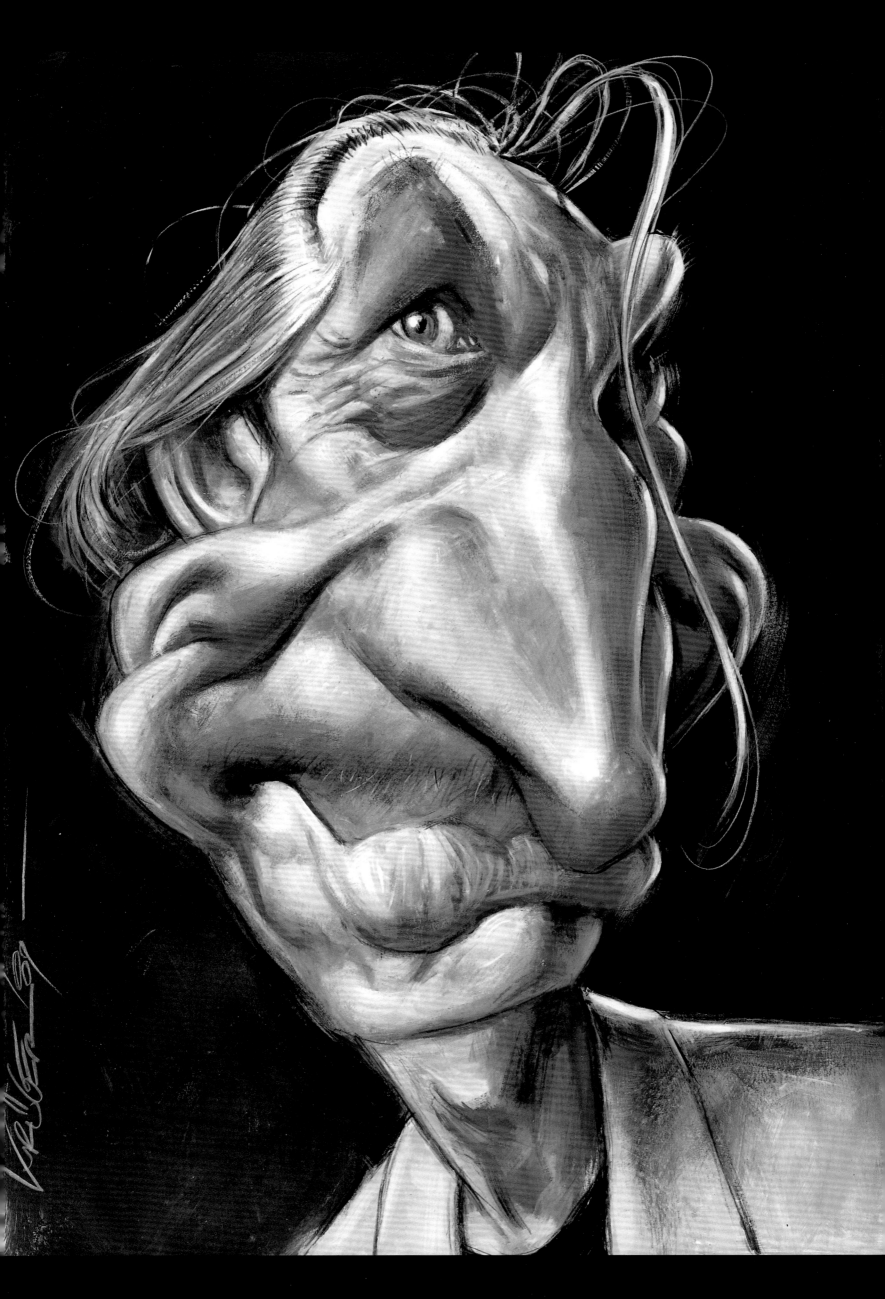

Friday, December 24, 1976
"Mick Jagger was there and he was in a good mood, he asked me what I thought of A Star is Born *and I told him and he said he was so happy he'd turned it down, that he didn't want to play a has-been rock singer, even for the million they offered him. Mick was asking for coke and finally got some from Anselmino. Fred's housekeeper Hazel made turkey and ham and brussels sprouts. Paloma Picasso and her entourage were there."*

Sunday, June 26, 1977
"Earl and I discussed the cover of the Rolling Stones album that I'm doing. He wanted me to put some writing on it."

Monday, June 5, 1978
"Mick opened the door. I thought he wouldn't be there. He was on his way up to Woodstock. I asked him if it was true that he'd bought 200 acres up there and he said no, that he was just living upstairs from a dump. He showed me their new album and the cover looked good, pullout, die-cut, but they were back in drag again! Isn't that something? After we left the Carlyle I told Jerry I thought Mick had ruined the Love You Live *cover I did for them by writing all over it - it's his handwriting, and he wrote so big. The kids who buy the album would have a good piece of art if he hadn't spoiled it."*

Andy Warhol, "The Diaries"

Freitag, den 24. Dezember 1976
„Mick Jagger war bester Laune und fragte mich nach meiner Meinung über *A Star is Born*. Ich sagte sie ihm, und er war doppelt froh, daß er die Rolle abgelehnt hatte. Er wollte keinen Rocksänger spielen, mit dem es bergab ging, auch nicht für die Million, die man ihm geboten hatte. Mick verlangte nach Koks, Anselmino gab ihm welches. Freds Haushälterin Hazel servierte Truthahn, Schinken und Rosenkohl. Paloma Picasso war mit ihrem Anhang da."

Sonntag, den 26. Juni 1977
„Earl und ich diskutierten über das Cover, das ich für die Rolling Stones entwerfe. Er meint, daß ich etwas mit Schrift machen soll."

Montag, den 5. Juni 1978
„Mick öffnete die Tür. Ich war überrascht, ihn anzutreffen. Ich vermutete ihn auf dem Weg nach Woodstock. Als ich ihn fragte, ob er dort oben tatsächlich 80 Hektar Land gekauft habe, sagte er nein. Er zeigte mir das neue Stones-Album. Das Cover ist gut, ausklappbar und ausgestanzt, und sie haben schon wieder Frauenklamotten an. Ist das nichts? Als wir das Carlyle verließen, sprach ich mit Jerry (*Anm.:* Hall) über das Cover von *Love You Live*, das ich entworfen habe. Mick hat es meiner Meinung nach verdorben. Er hat überall hingekritzelt, und dann auch noch so groß. Es ist eindeutig seine Schrift. Die Kids, die das Album kaufen, hätten ein schönes Stück Kunst bekommen, wenn er es nicht versaut hätte."

Andy Warhol, „Das Tagebuch"

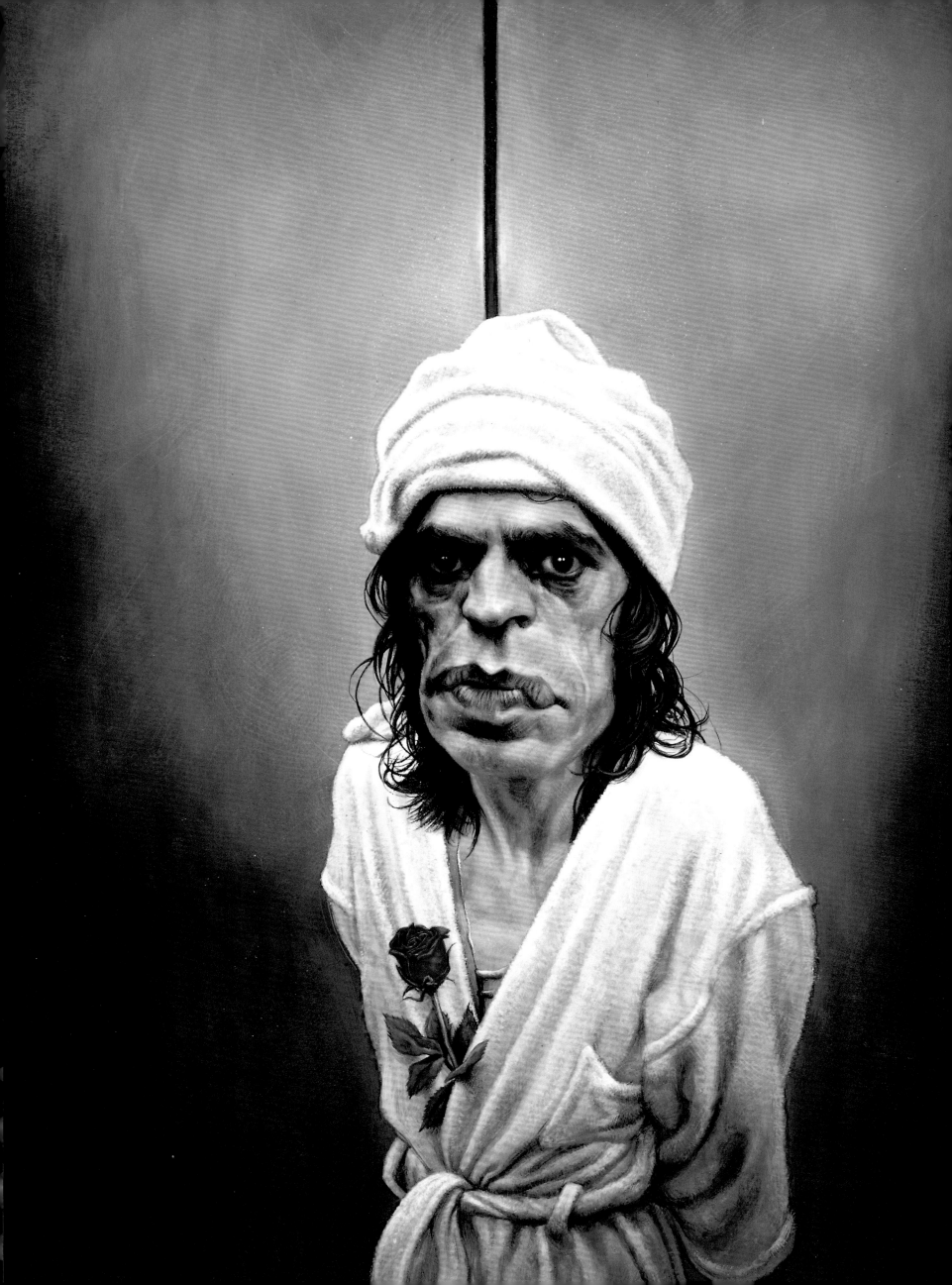

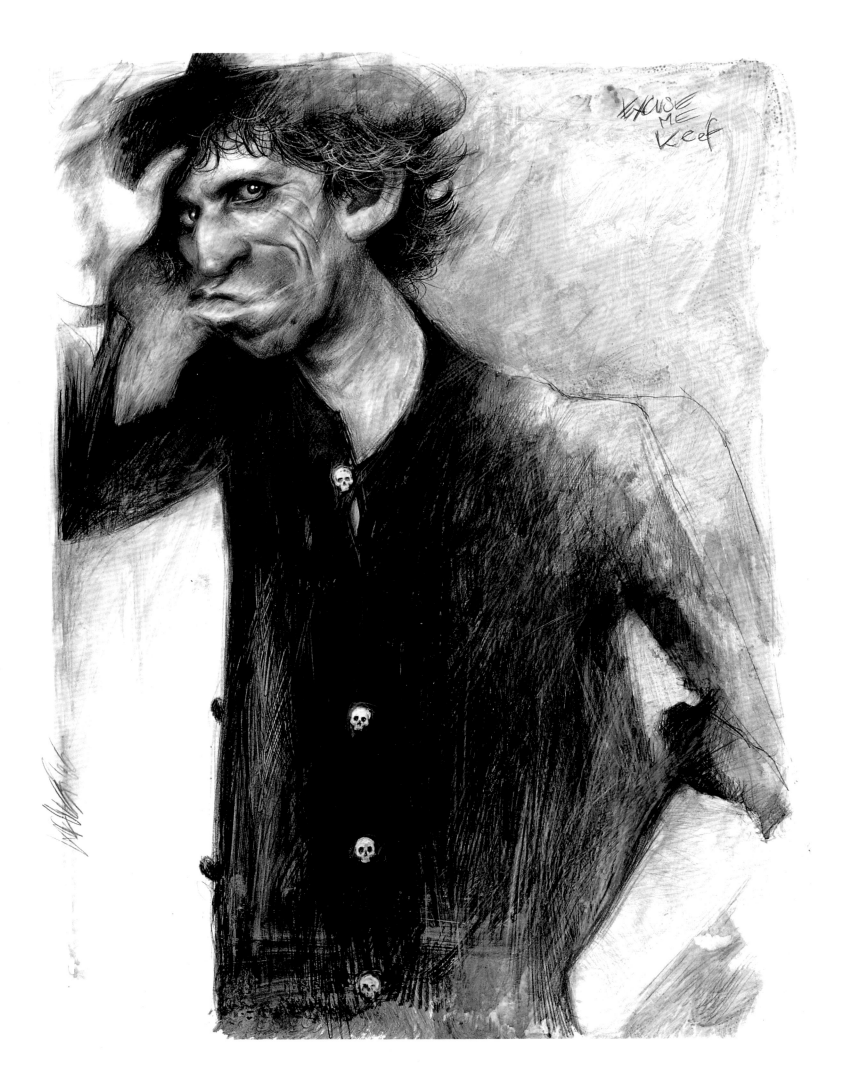

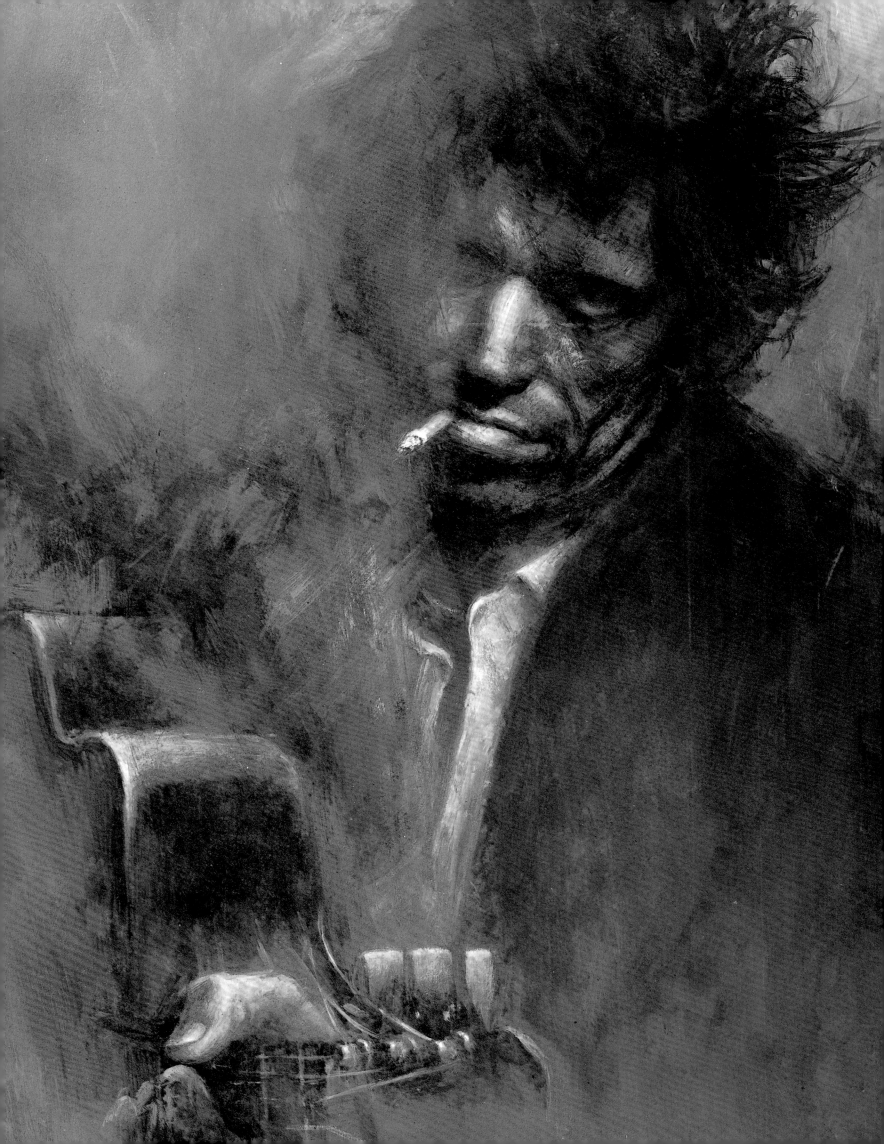

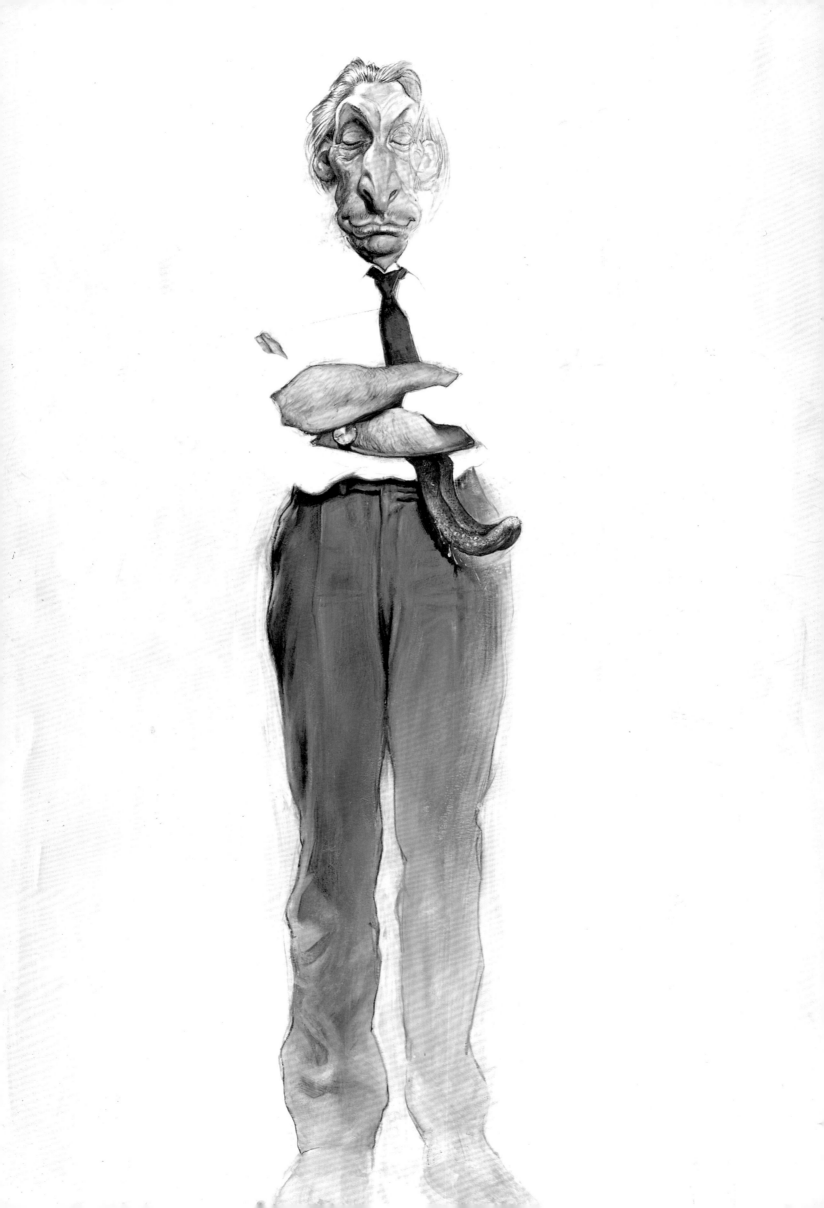

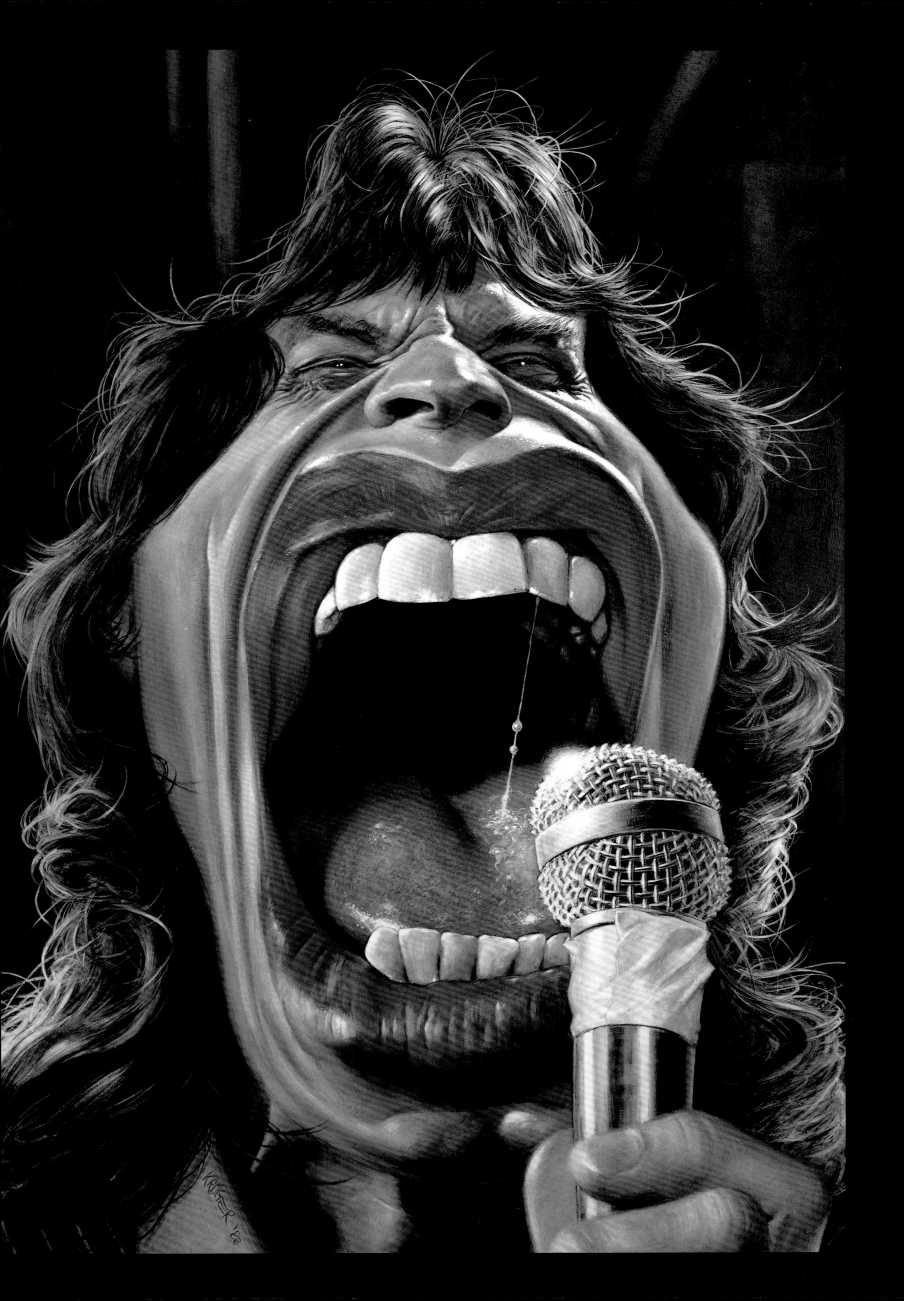

"The question is frequently asked:
Why does a man become a drug
addict? The answer is that he
usually does not intend to be-
come an addict. You don't wake
up one morning and decide to
be a drug addict.
You become a narcotics addict
because you do not have strong
motivations in any other direc-
tion. Junk wins by default.
Junk is not, like alcohol or weed,
a means to increased enjoyment
of life. Junk is not a kick. It is a
way of life."
W. S. Burroughs, "Junky", 1953

"It's only the periods with nothing
to do that got me into heroin. It
was more of an adrenaline imba-
lance. You have to be an athlete
out there, but when the tour
stops, suddenly your body don't
know there ain't a show the next
night. The body is saying, 'Where's
the adrenaline? What am I gonna
do, leaping out in the street?' It
was a very hard readjustment.
I was glad to be home but still
hyper. And I found smack made it
much easier for me to slow down
very smoothly and gradually."

Keith Richards

„Häufig fragt man: Warum wird
ein Mensch rauschgiftsüchtig? Die
Antwort: Gewöhnlich beabsich-
tigt man nicht, süchtig zu wer-
den. Man wacht nicht eines
Morgens auf und beschließt es.
Man wird süchtig, weil man keine
anderen starken Interessen hat.
Opiat stößt immer in eine Lücke.
Opiat ist nicht wie Alkohol oder
Marihuana nur ein Mittel, um die
Freude am Leben zu steigern.

Opiat ist kein Rausch, es ist eine
Lebensweise."
William S. Burroughs, „Junkie', 1953

„Nur in den Zeiten, wenn ich
nichts zu tun hatte, nahm
ich Heroin. Mein Adrenalinstoff-
wechsel war dann irgendwie
gestört. Auf der Bühne muß man
jeden Tag in Topform sein, aber
wenn die Tour dann zu Ende ist,
weiß dein Körper nicht, daß es
am nächsten Abend keine Show
geben wird. Der Körper fragt, ,Wo
bleibt das Adrenalin? Was soll ich
machen, auf der Straße rumtan-
zen?' Die Umgewöhnung fällt sehr
schwer. Ich war froh, wieder zu
Hause zu sein, aber man ist noch
voll aufgedreht. Ich hab festge-
stellt, daß Heroin mir diese
Umstellung wesentlich leichter
gemacht hat - behutsam und
Schritt für Schritt."

Keith Richards

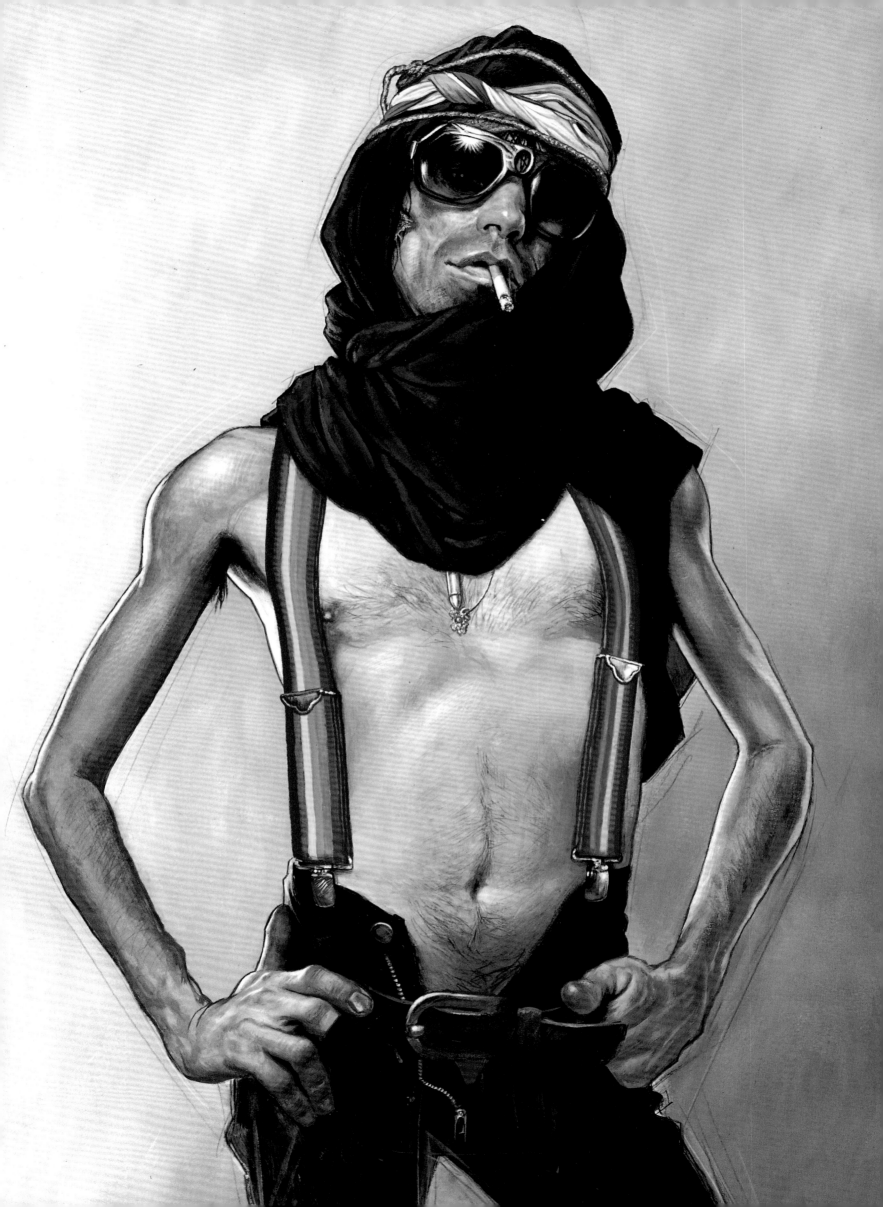

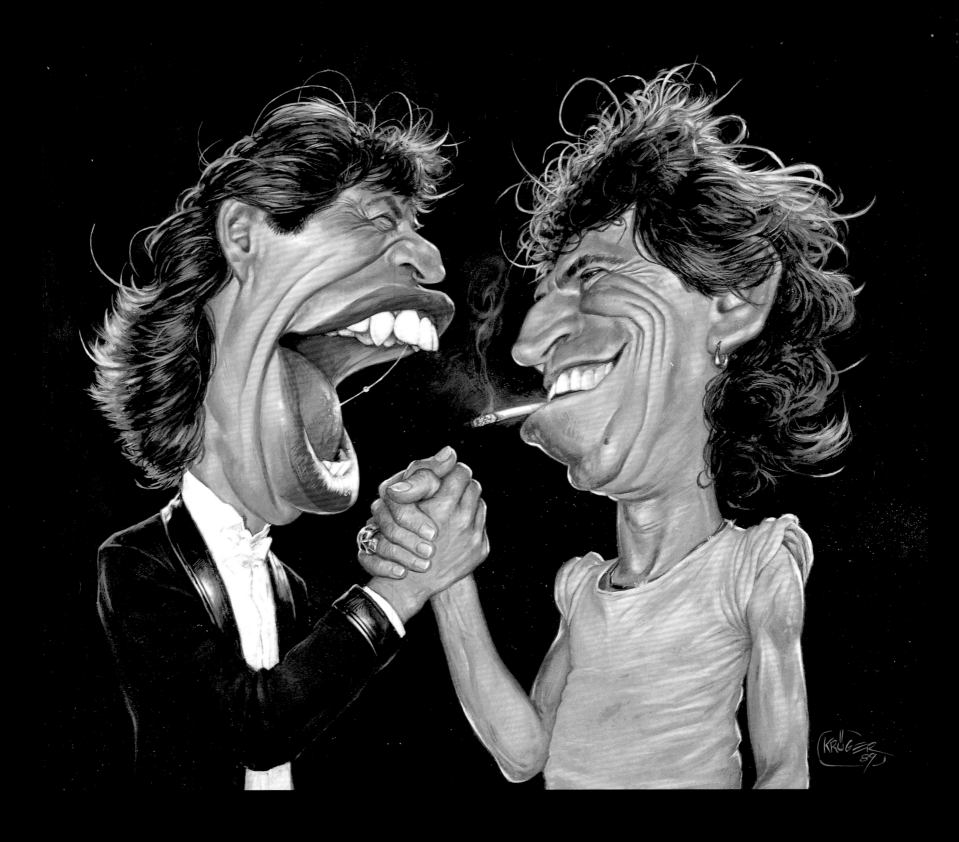

"The musical partnership between Richards and Jagger, enhanced by the extraordinary drumming of Watts, makes this still the best rock and roll music on stage today. With their publicized problems obviously in the past, Jagger and Richards can now get down to the business of performing live music. However divergent their lifestyles, on stage theirs is the quintessential symbiotic relationship of all time."

Lisa Robinson

„Die musikalische Partnerschaft zwischen Richards und Jagger, noch verstärkt durch Watts' außergewöhnliche Schlagzeugarbeit, ist nach wie vor der Garant für den besten Rock'n Roll unserer Tage. Jetzt, da ihre in der Öffentlichkeit breitgetretenen Probleme offenbar der Vergangenheit angehören, können sich Jagger und Richards wieder voll und ganz auf ihre Musik konzentrieren. So unterschiedlich ihr persönlicher Lebensstil auch sein

mag, auf der Bühne stellen sie die perfekteste Symbiose aller Zeiten dar."

Lisa Robinson

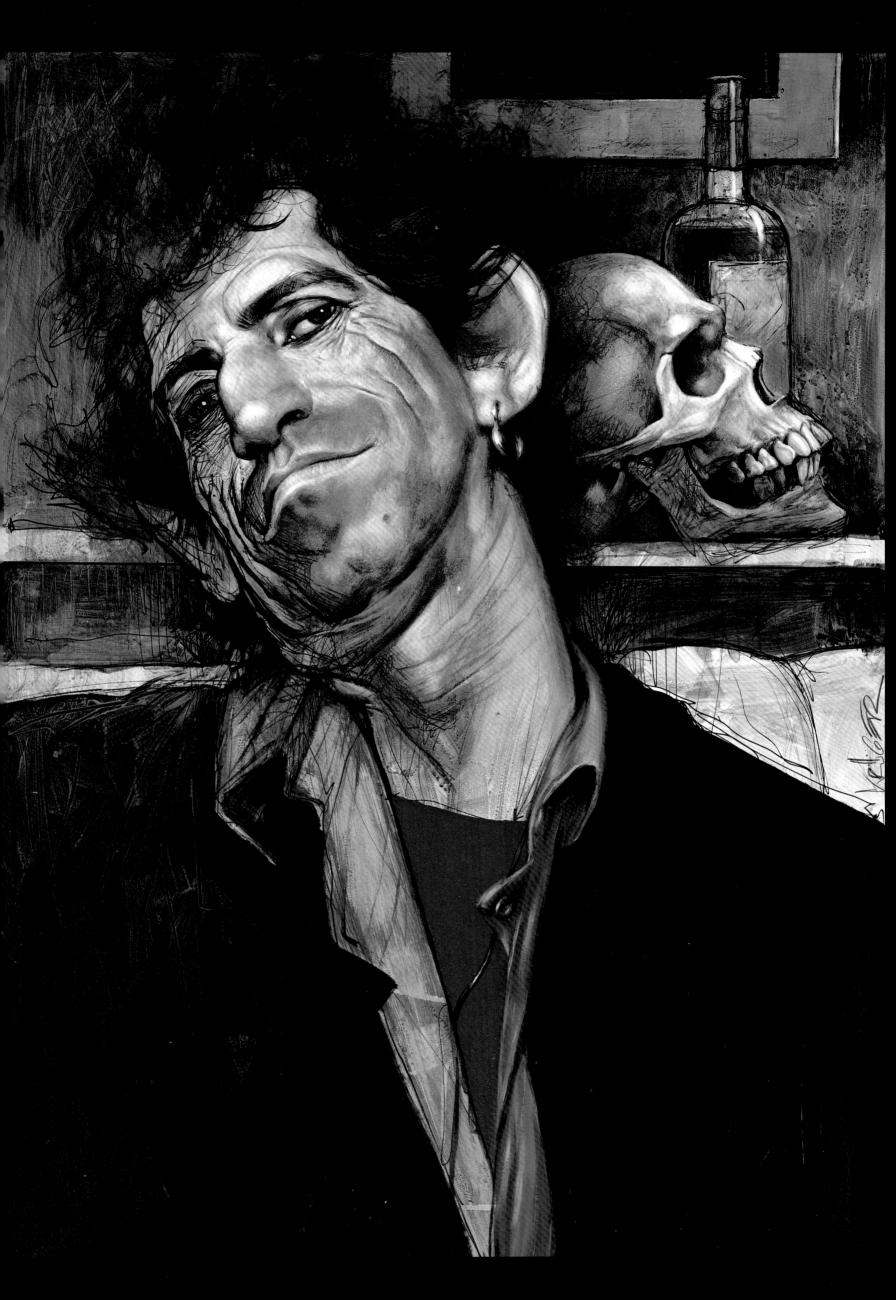

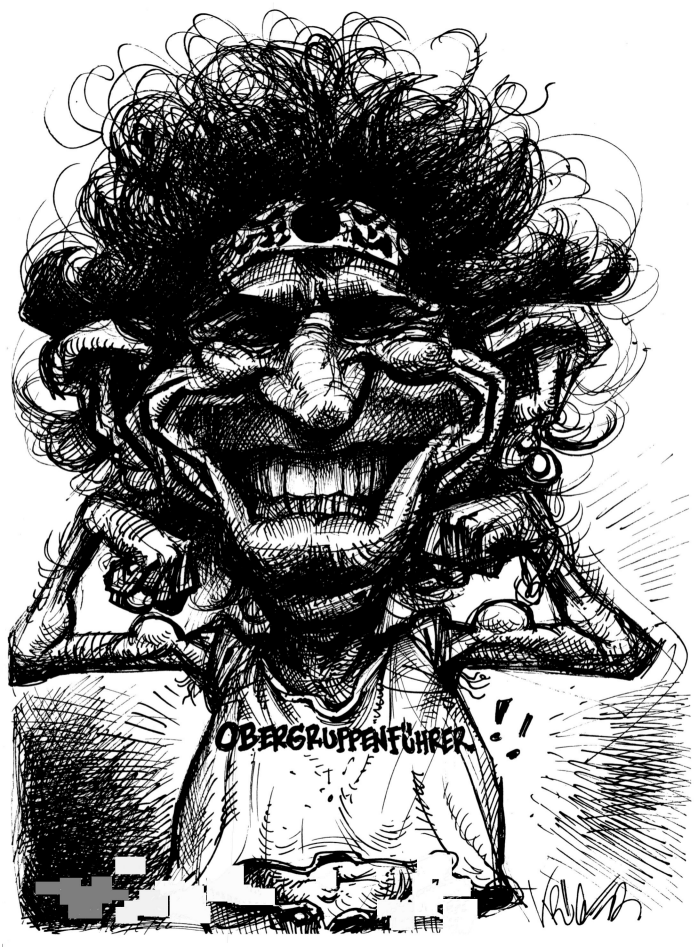

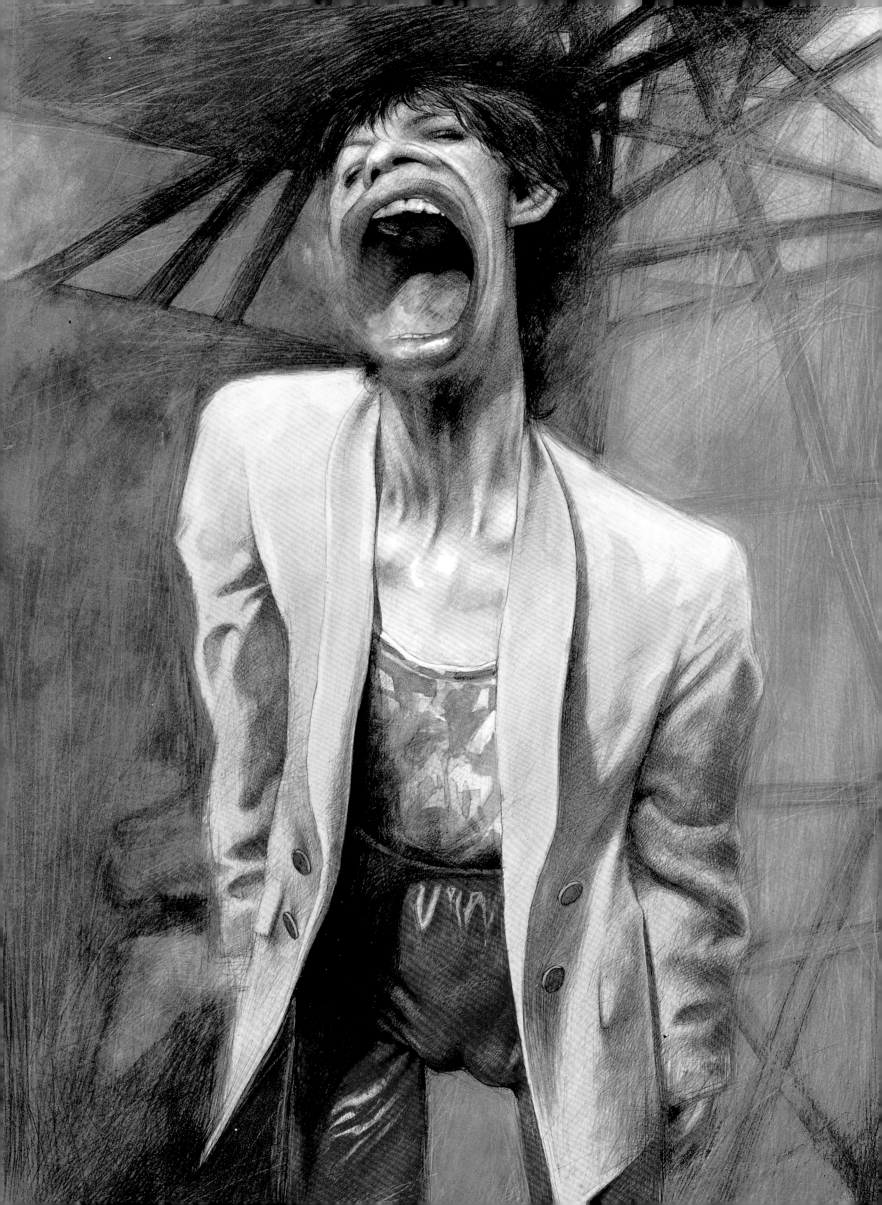

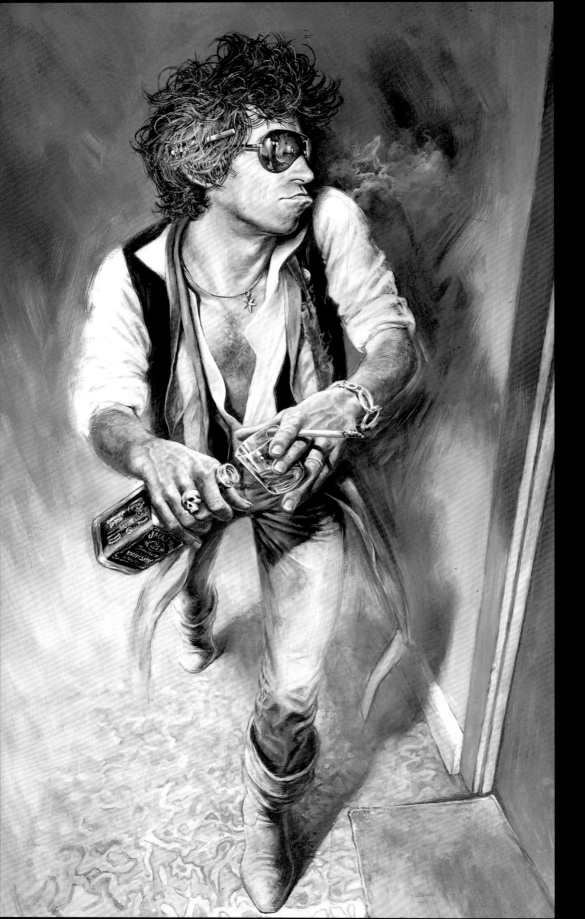

"There's always this thing in show business - you have an 'image', and you play it to the hilt. I'm not the guys I see on MTV who obviously think they're me. There are so many people who think that's all there is to it. It's not that easy to be Keith Richards. But it's not so hard, either. The main thing is to know yourself."

Keith Richards

„Im Showbusiness hat jeder sein ganz bestimmtes Image, dem man so gut wie's geht nachzukommen versucht.
Ich bin nicht so wie die Typen, die ich auf MTV sehe und die sich offenbar einbilden, sie wären Keith Richards. Es gibt so viele Leute, die nur die äußere Fassade sehen. Es ist nicht leicht, Keith Richards zu sein - aber so schwer nun auch wieder nicht. Hauptsache, man weiß selbst, wer man ist."

Keith Richards

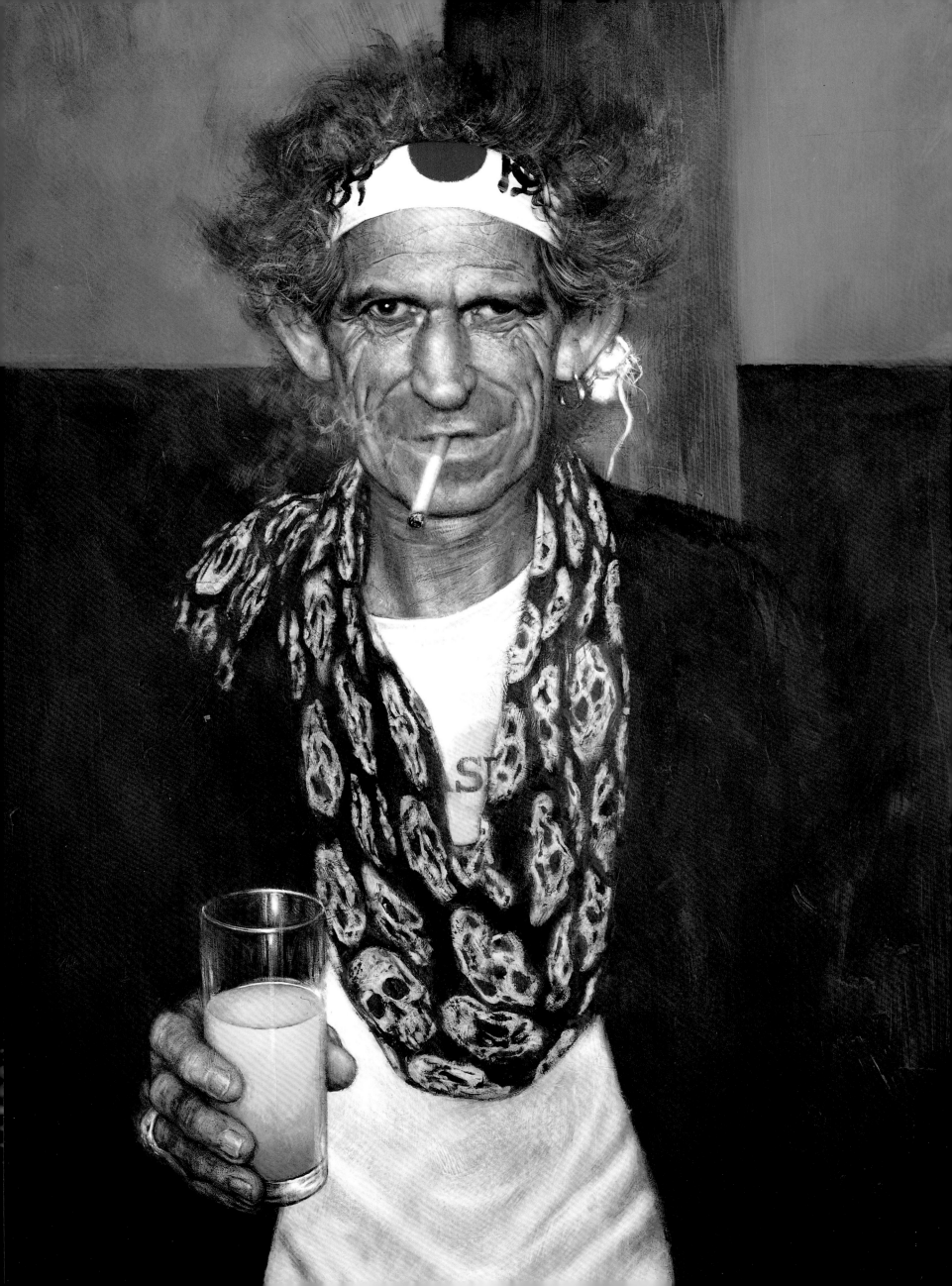

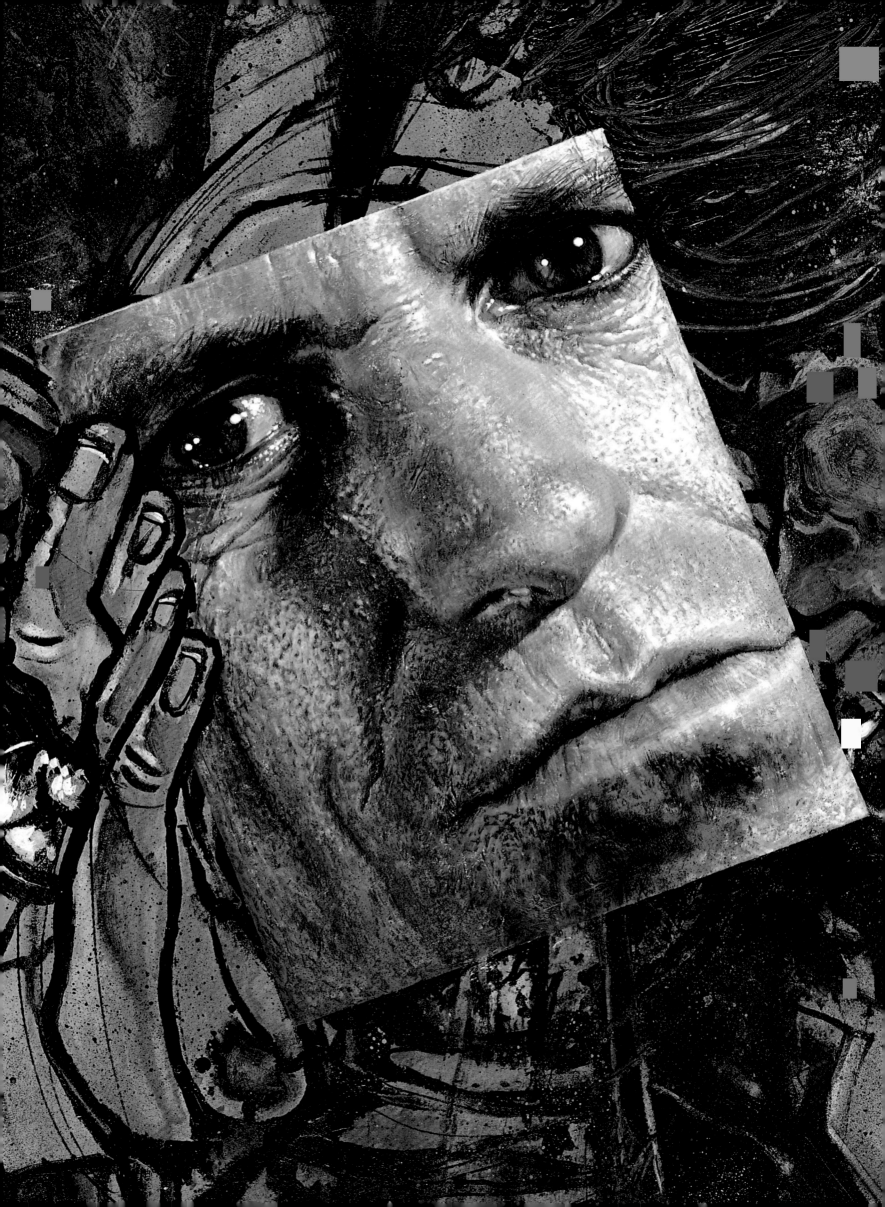

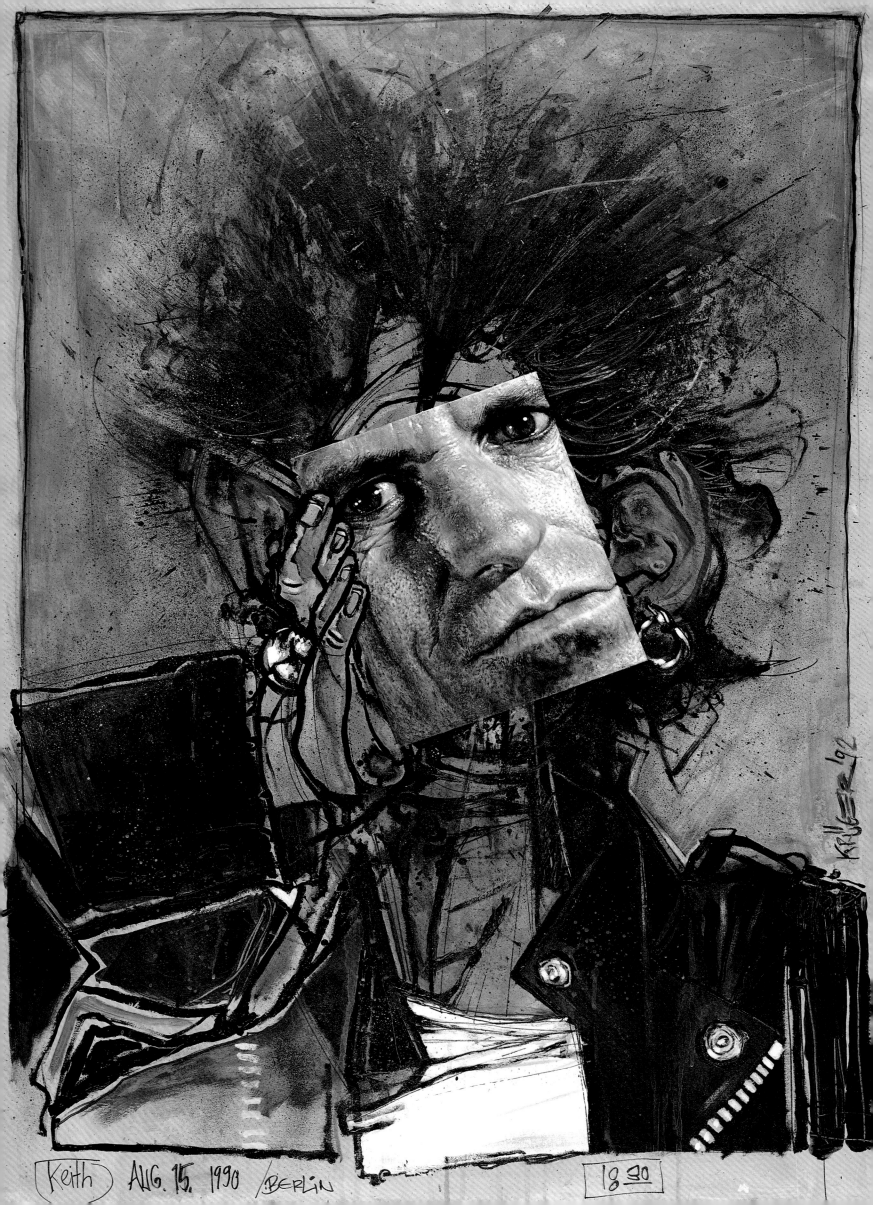

Keith AUG. 15. 1990 /BERLIN 18 30

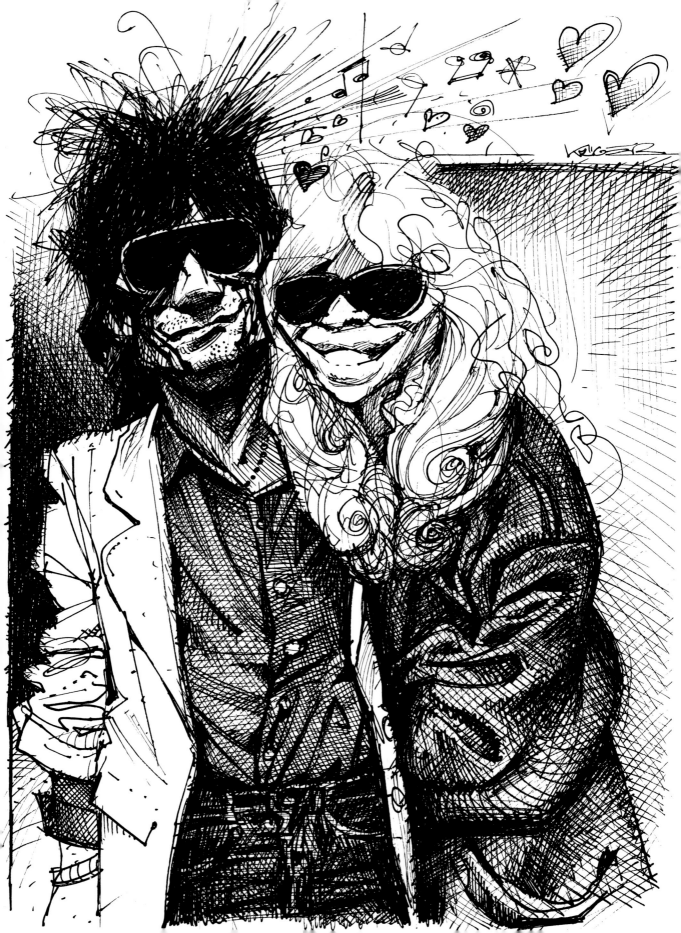

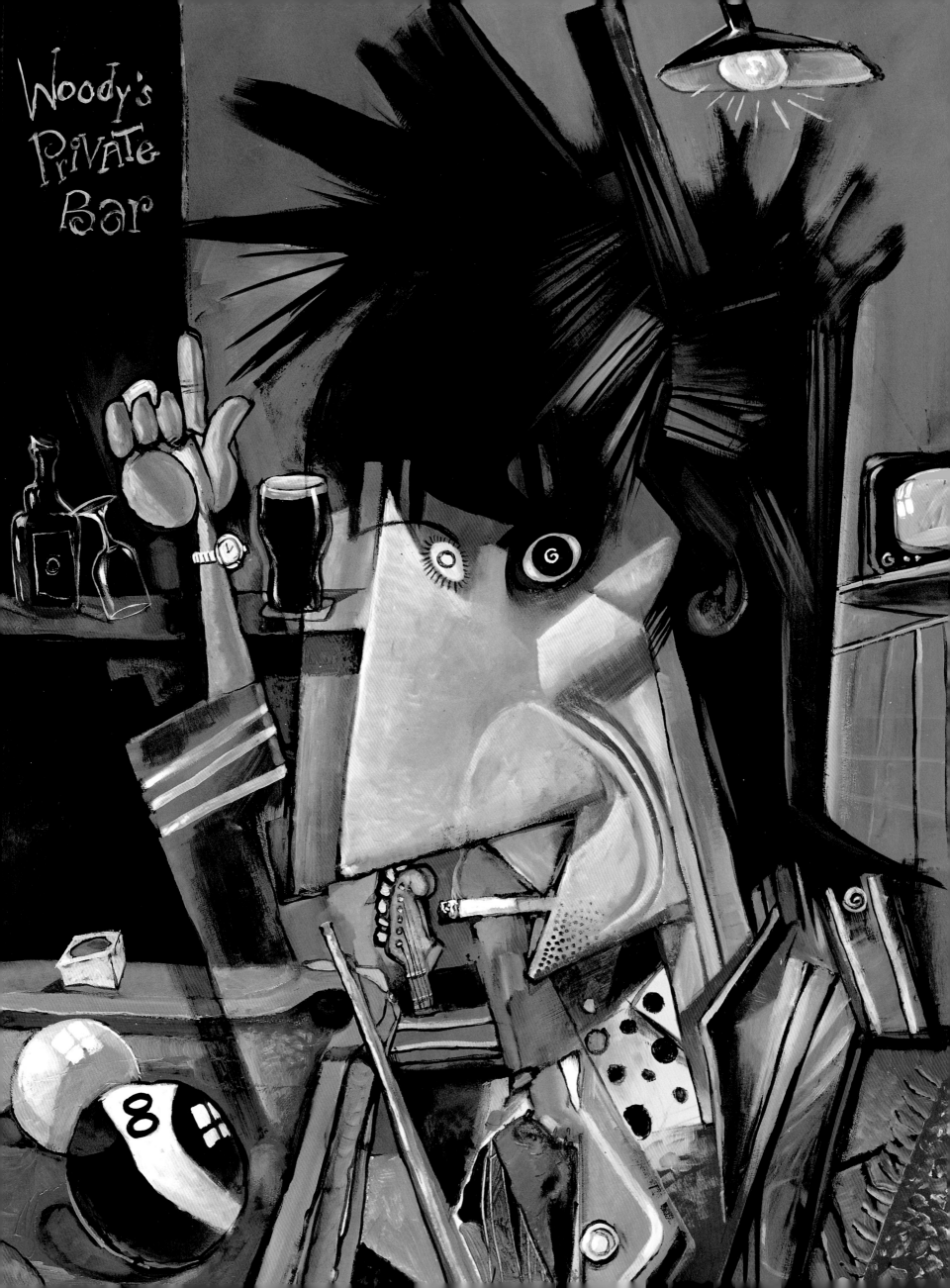

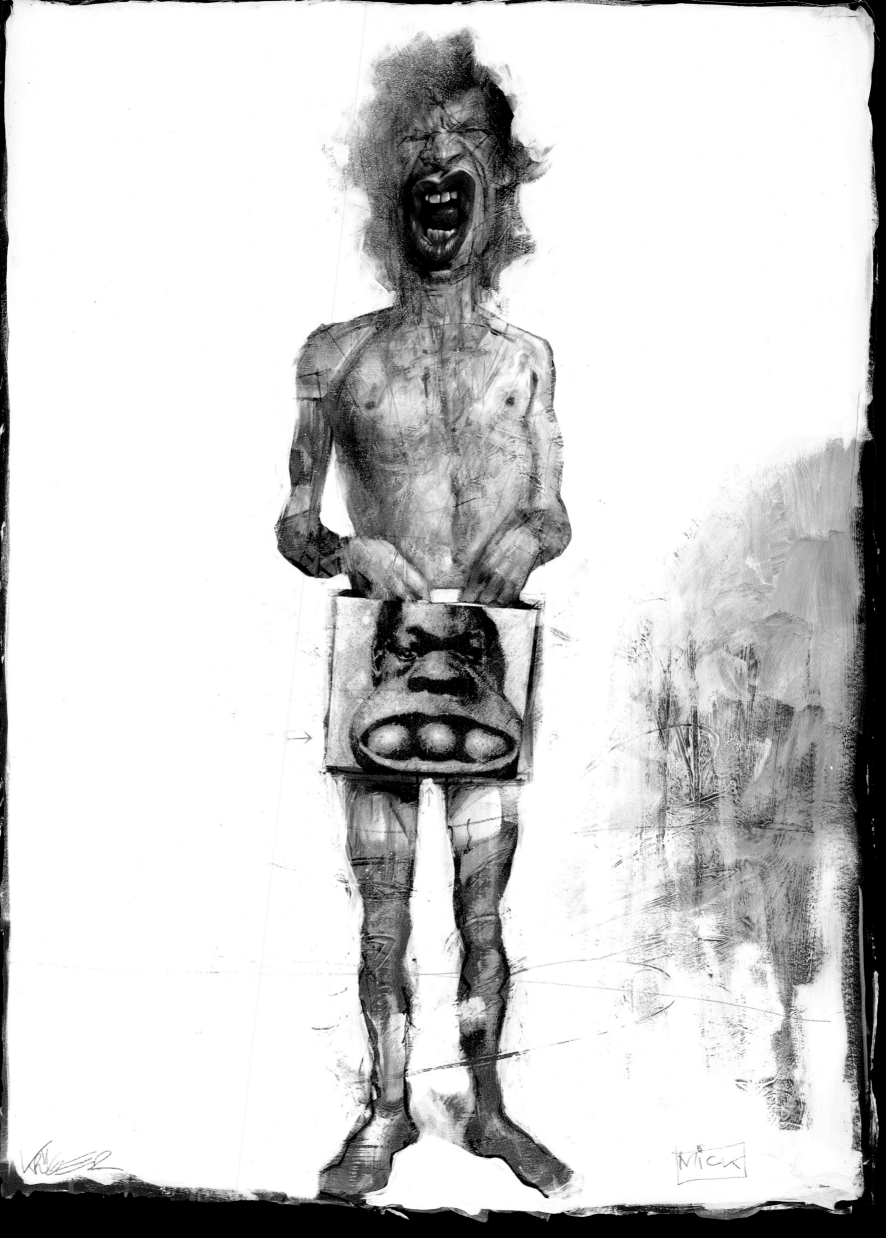

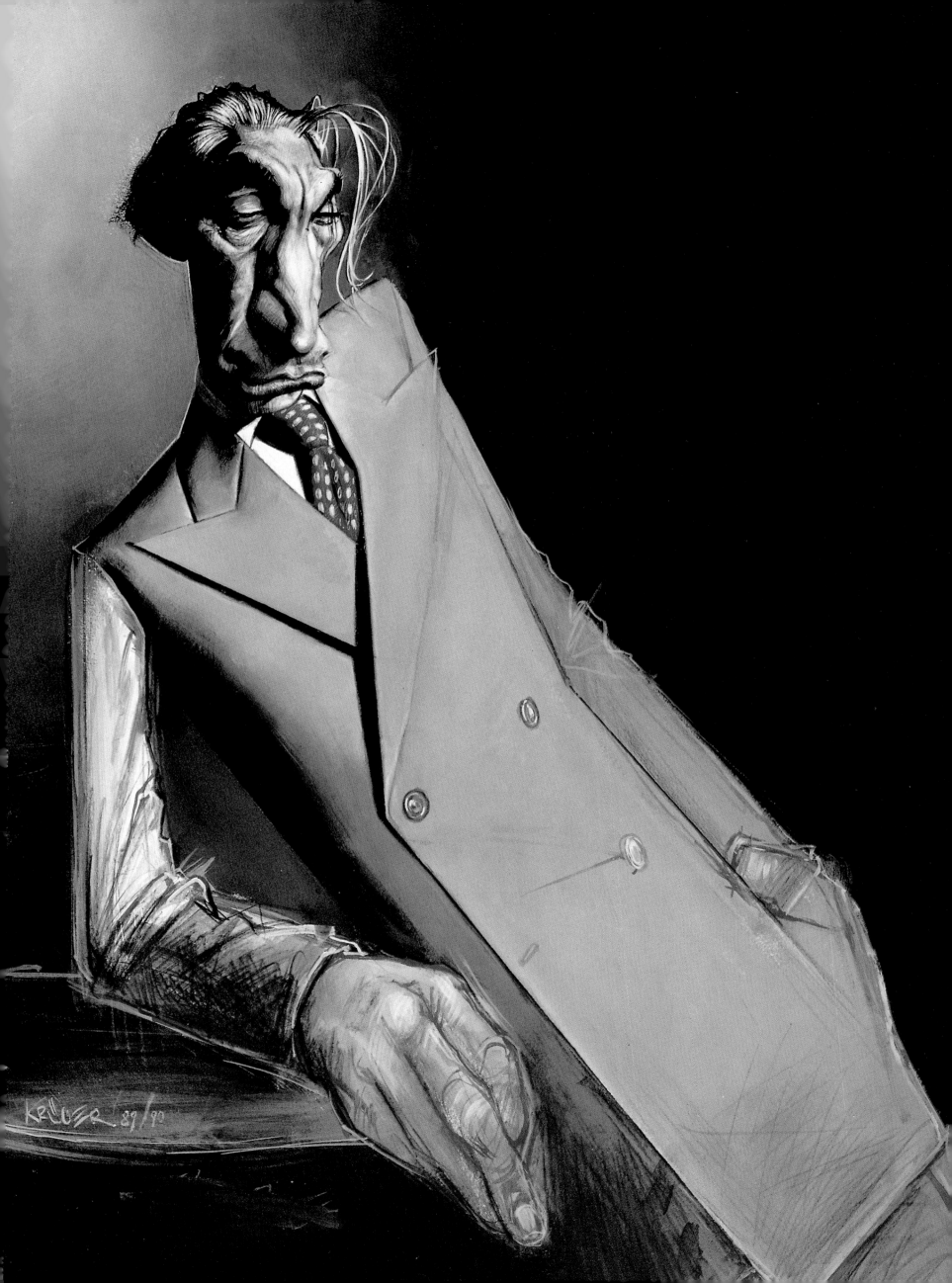

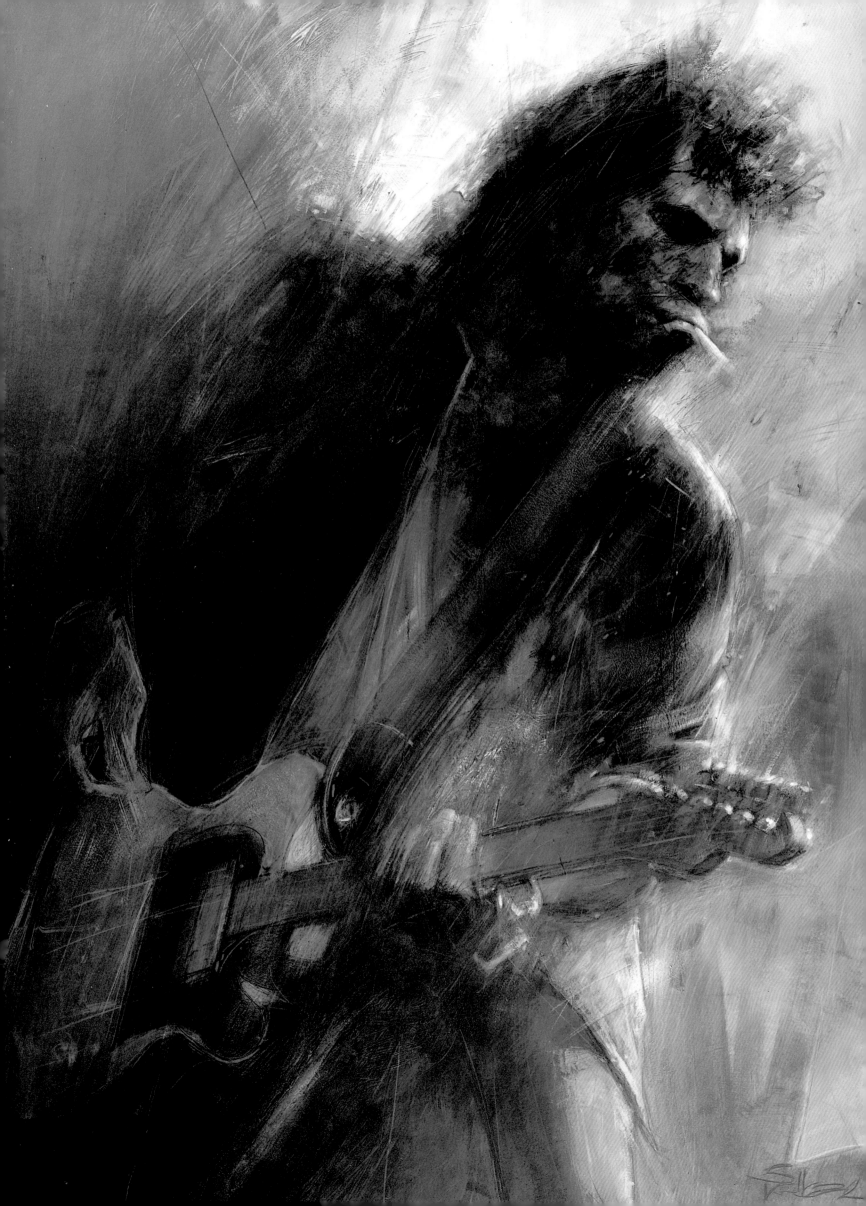

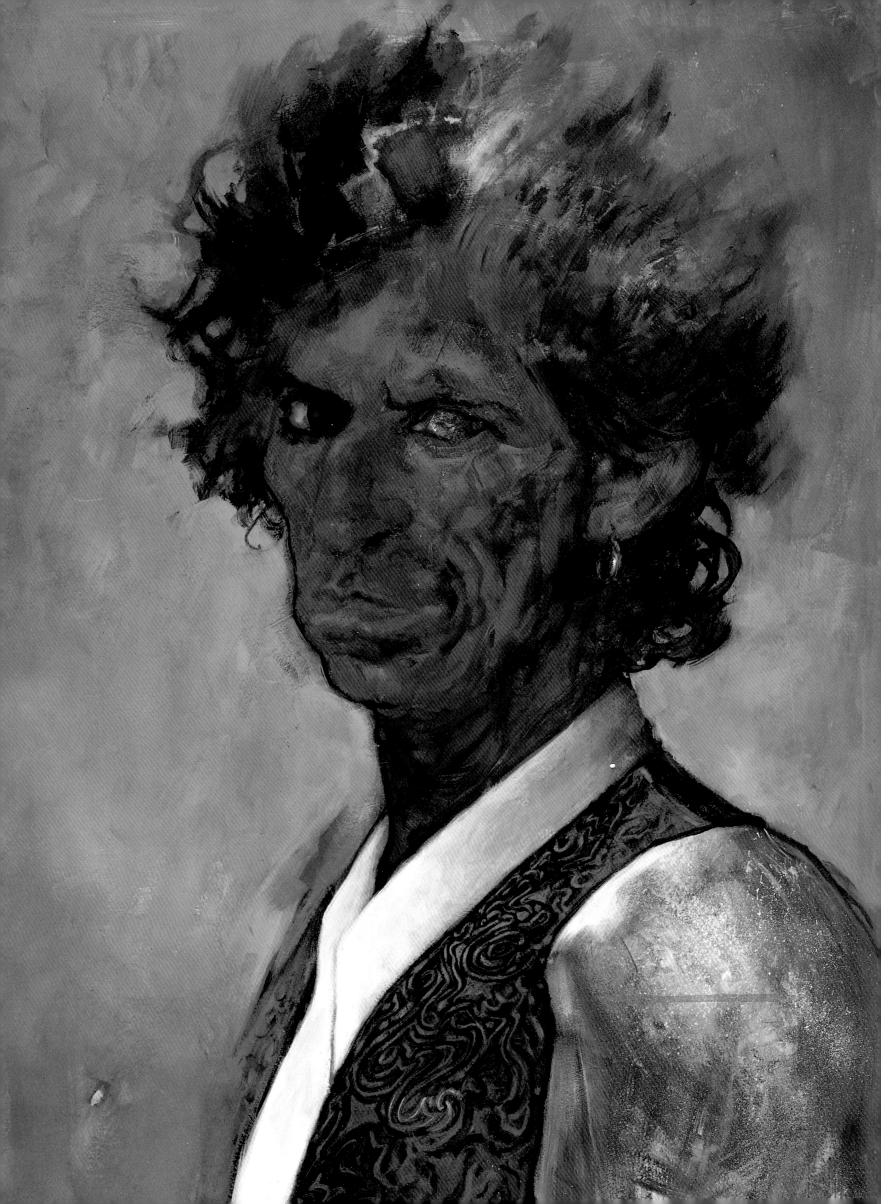

them. I knew it from the start.
Honest."

Ron Wood

brachte kraftsprühende musikali-
sche Impulse und seine starke,

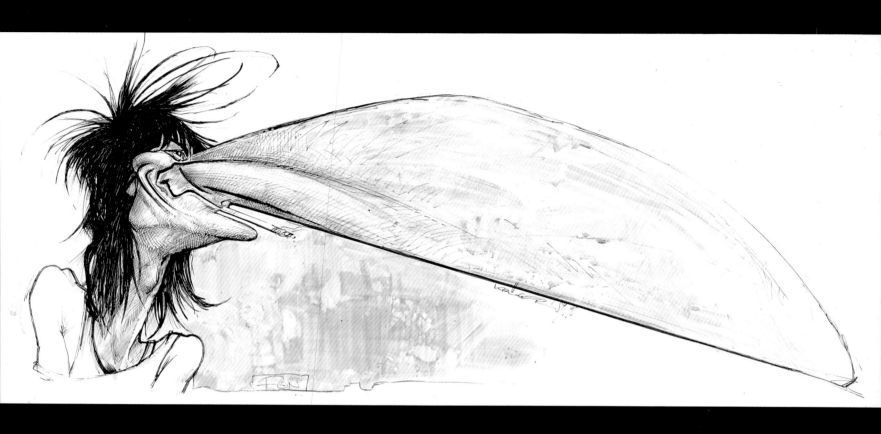

"After four months of nego-
tiations, on 14 April 1975, Ron
was confirmed our new man. He
brought musical vitality and a
powerful likeable personality into
our ranks. Crucially, too, Ron has
always been a positive influence
in soothing tensions in the band.
He's able to hang out with us all
in turn."

Bill Wyman

„Ich hatte schon immer ein ziemli-
ches Auge auf die Stones gewor-
fen. Zuallererst war ich ein echter
Fan. Aber noch wichtiger war,
daß ich wußte, daß ich dazu
bestimmt war, einer von ihnen zu
werden. Ich wußte es von Anfang
an. Ehrlich."

Ron Wood

liebenswerte Persönlichkeit in
unsere Gruppe ein. Es muß auch
noch erwähnt werden, daß es
Ron stets gelungen ist, seinen
positiven Einfluß geltend zu ma-
chen und Spannungen in der
Band abzubauen. Er versteht es,
sich gegenüber jedem von uns
ungezwungen zu geben."

Bill Wymann

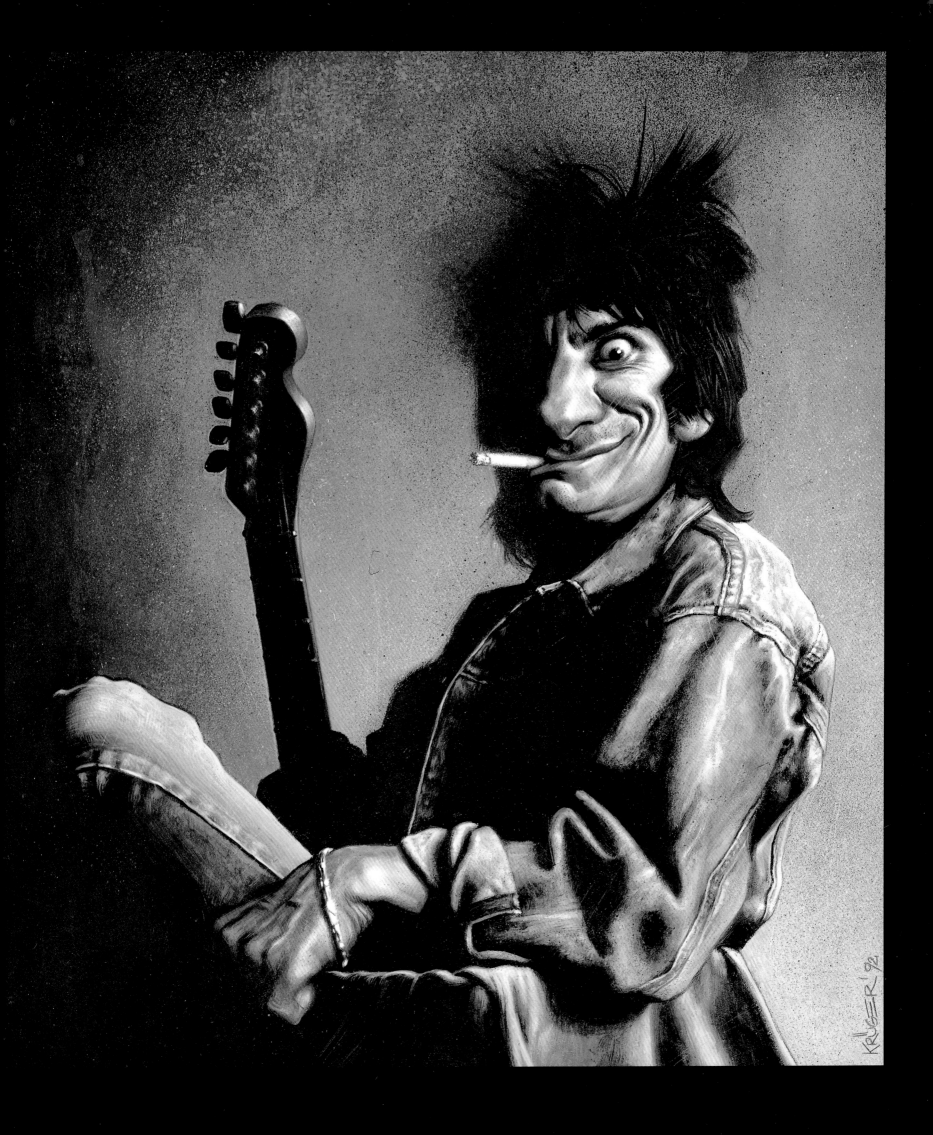

Keith has the constitution of concrete. He's like a cliff. The sea comes and washes up against it and it stands. But so many people who were around him would just collapse. Keith is the sort of person who can stay awake for three days without substances and all of a sudden fall asleep in midsentence sitting up and not moving for a few hours. He would just be up and up and up and up and up and all of a sudden it would be like a light switch, bing! But in certain strange positions. Then you would walk around him."

Richard Lloyd

"I'd been up for nine days. I was working on something in the studio and I put a tape in the machine to hear the latest blast I'd gotten. I turned around and fell asleep for a millisecond and I collapsed into the corner of a JBL speaker. You know what noses are like. Great nap, waking to this red shower. I think I gave it a slight curve to the left. It was just that life was so interesting for nine days that I couldn't give it up. Not even for a minute."

Keith Richards

„Keith besitzt die Konstitution von Beton. Er ist wie eine Klippe. Er steht wie ein Fels in der Brandung. Aber viele seiner Freunde waren diesem Druck nicht gewachsen und sind zusammengebrochen. Keith kann ohne weiteres drei Tage hintereinander durchmachen, aber mitten im Satz schläft er dann urplötzlich ein und sitzt anschließend stundenlang völlig reglos da. Er wirkt wie aufgedreht, doch von einer

Sekunde auf die andere setzt es bei ihm aus. Blackout - wie bei einem Lichtschalter, bing! Das passiert an den unmöglichsten Orten, und dann muß man einen großen Bogen um ihn machen."

Richard Lloyd

„Ich hatte seit neun Tagen nicht mehr geschlafen. Ich war mit Studioarbeiten beschäftigt und wollte mir gerade das Band meiner letzten Aufnahme anhören, als ich für eine tausendstel Sekunde eingenickt und dabei gegen meine Lautsprecherbox geknallt bin. Sie wissen ja, wie empfindlich so eine Nase ist; als ich wieder zu mir kam, war alles voller Blut. Ich glaube, mein Zinken stand etwas nach links. Aber das Leben war neun Tage lang so interessant, daß ich einfach nicht aufhören konnte. Nicht mal für eine Minute."

Keith Richards

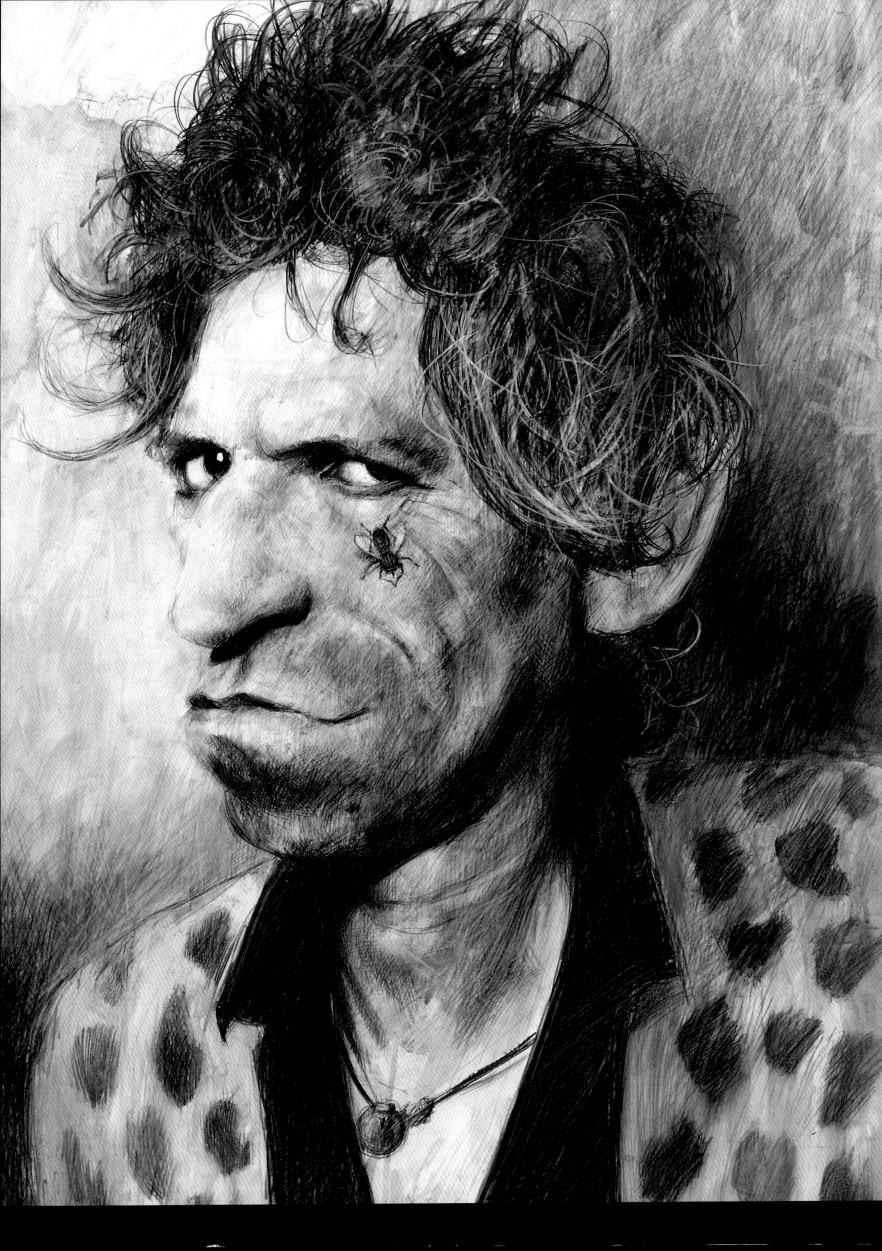

KEITH!

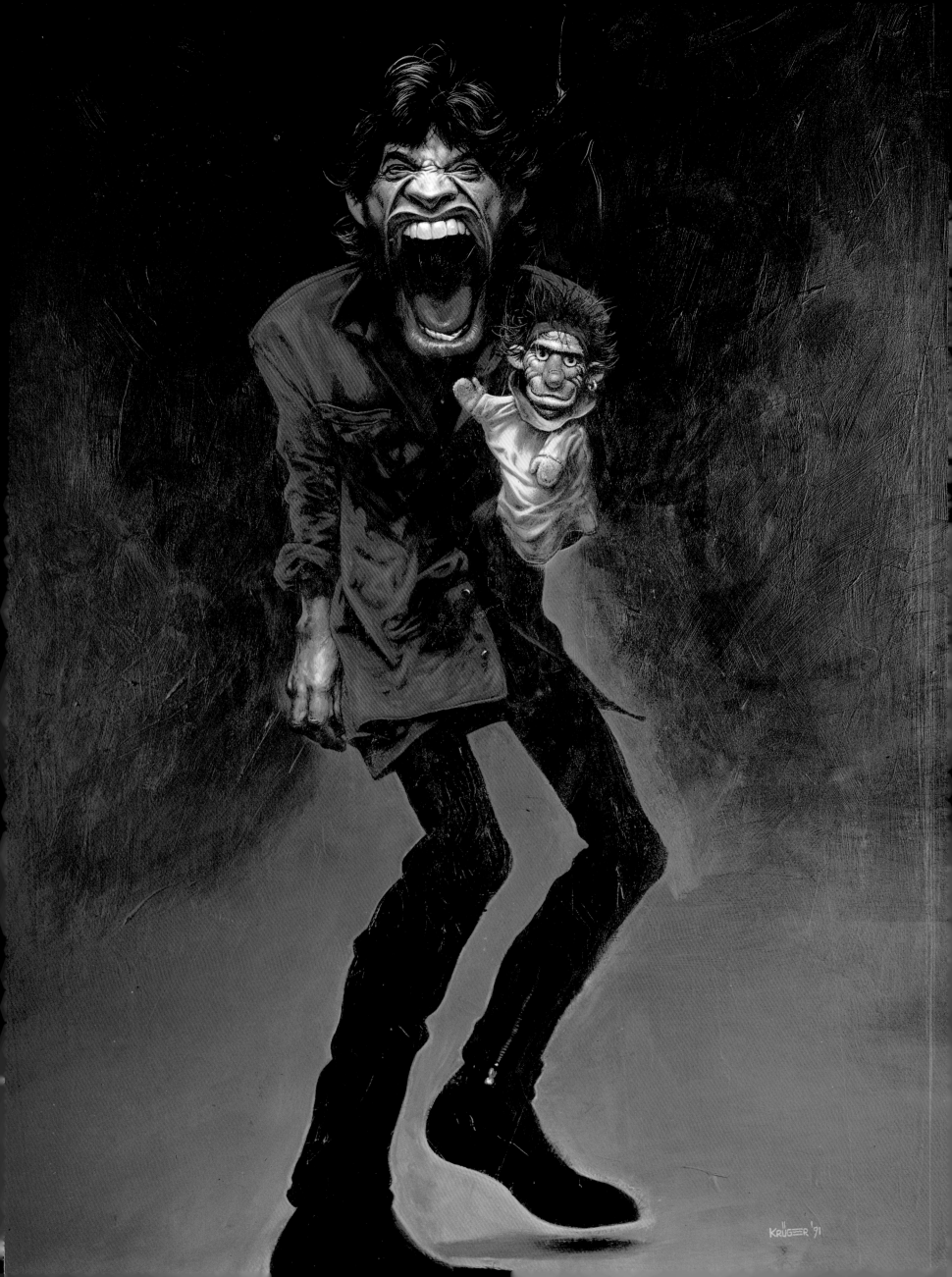

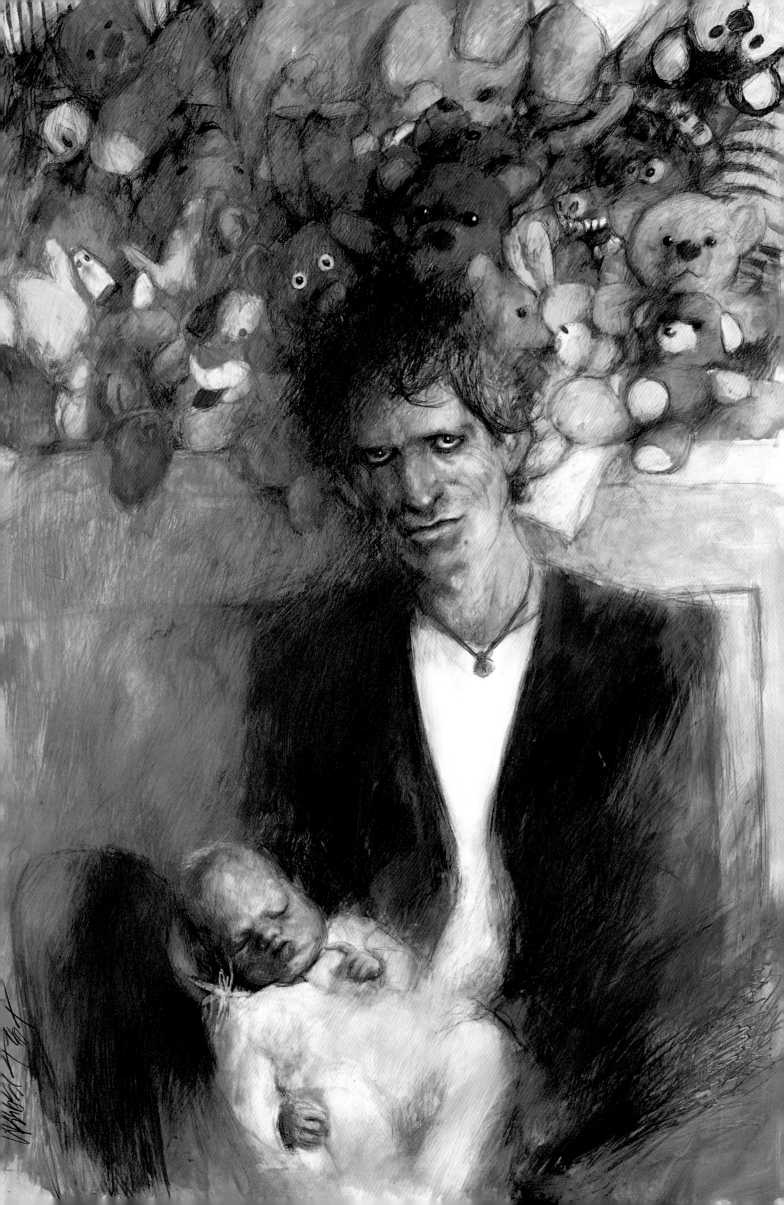

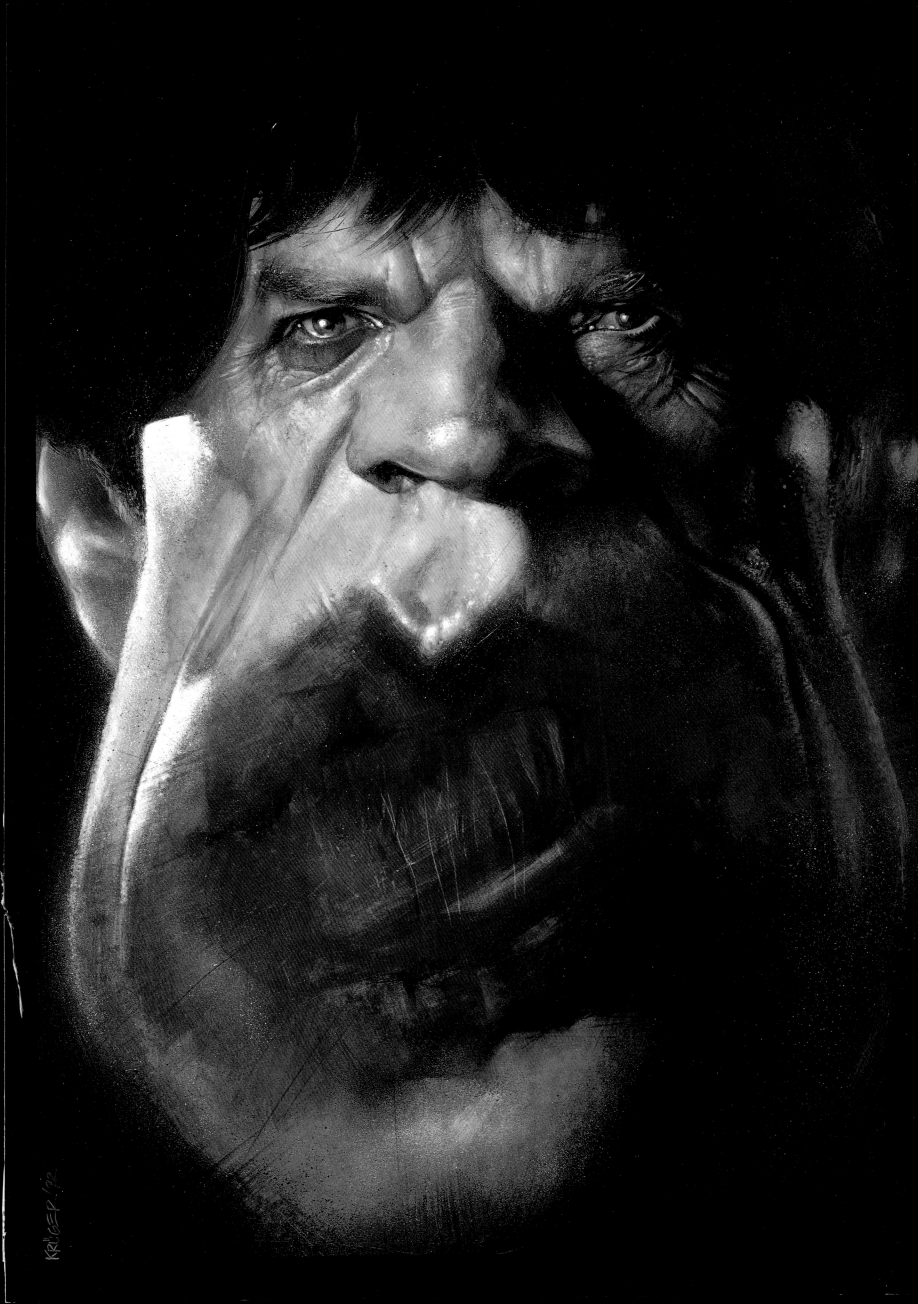

"Joe the Dead belongs to a select breed of outlaws known as the NOs, natural outlaws dedicated to breaking the so-called natural laws of the universe foisted upon us by physicists, chemists, mathematicians, biologists and, above all, the monumental fraud of cause and effect, to be replaced by the more pregnant concept of synchronicity.

Ordinary outlaws break man-made laws. Laws against theft and murder are broken every second. You only break a natural law once. To the ordinary criminal, breaking a law is a means to an end: obtaining money, removing a source of danger or annoyance. To the NO, breaking a natural law is an end in itself: the end of that law."

William S. Burroughs
"Western Lands"

„Der tote Joe gehört zu einer besonderen Art von Gesetzlosen, die als ‚Naturgesetzlose' (NGs) bekannt sind. Ihr Ziel ist es, die sogenannten Naturgesetze des Universums zu brechen, die uns aufgepfropft wurden von Physikern, Chemikern, Mathematikern, Biologen und vor allem von dem monumentalen Schwindel von Ursache und Wirkung, der ersetzt werden muß durch das sinnvollere Konzept des Synchronismus. Gewöhnliche Gesetzlose brechen Gesetze, die von Menschen geschaffen sind. Gesetze gegen Diebstahl und Mord werden in jeder Sekunde gebrochen. Ein Naturgesetz bricht man nur einmal. Für den gewöhnlichen Kriminellen ist Gesetzesbruch ein Mittel zum Zweck - um zu Geld zu kommen oder etwas zu beseitigen, das ihn ärgert oder bedroht. Für den NG ist das Brechen eines Naturgesetzes ein Zweck an sich: Das Ende jenes Gesetzes."

William S. Burroughs,
„Western Lands"

I've lived my life in my own way,
and I'm here because
I've taken the trouble to find out
who I am.

Keith Richards

Ich lebe mein Leben auf meine Weise,
und ich bin hier,
weil ich mir die Mühe gemacht habe
herauszufinden, wer ich bin.

Keith Richards

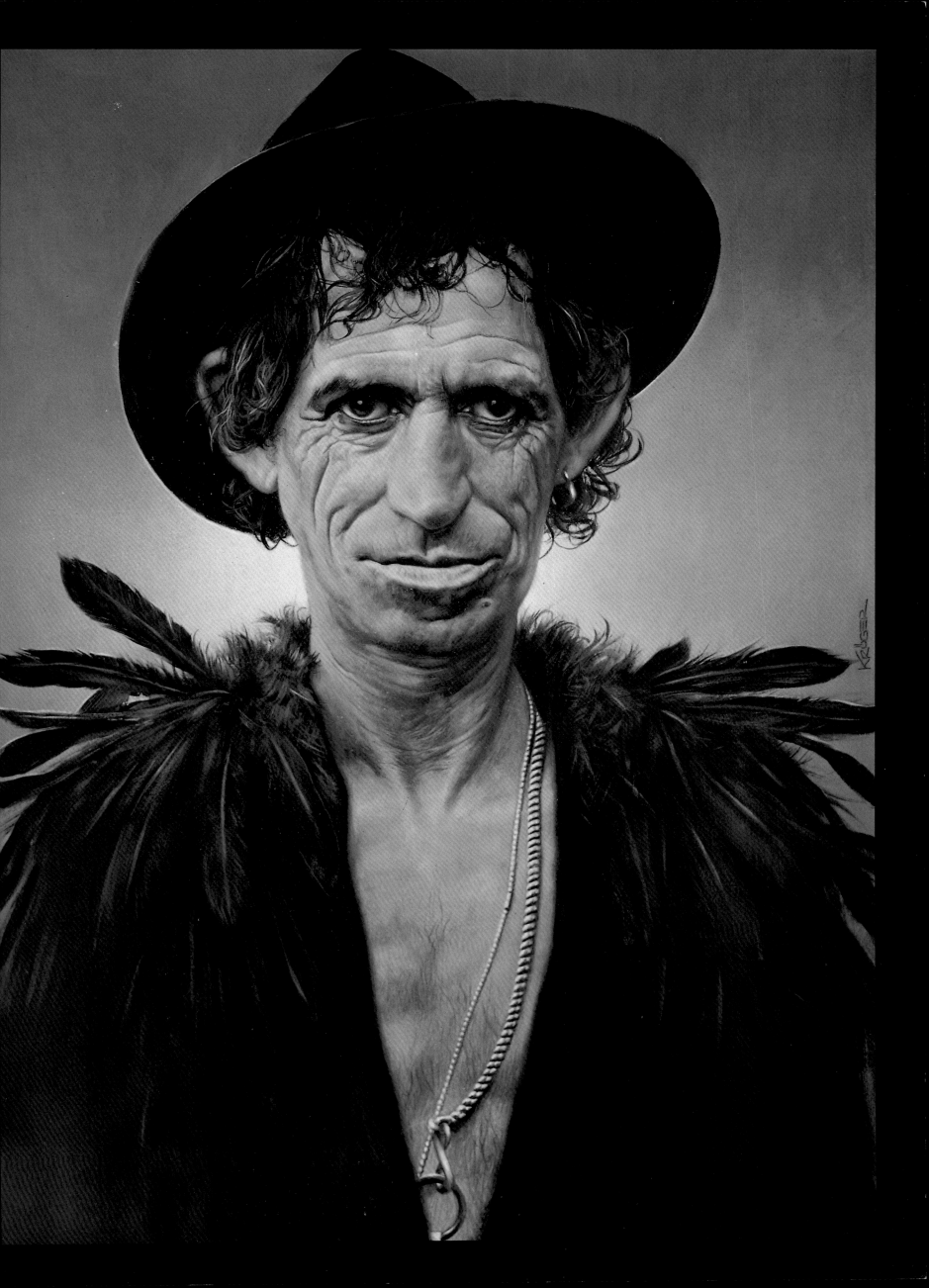

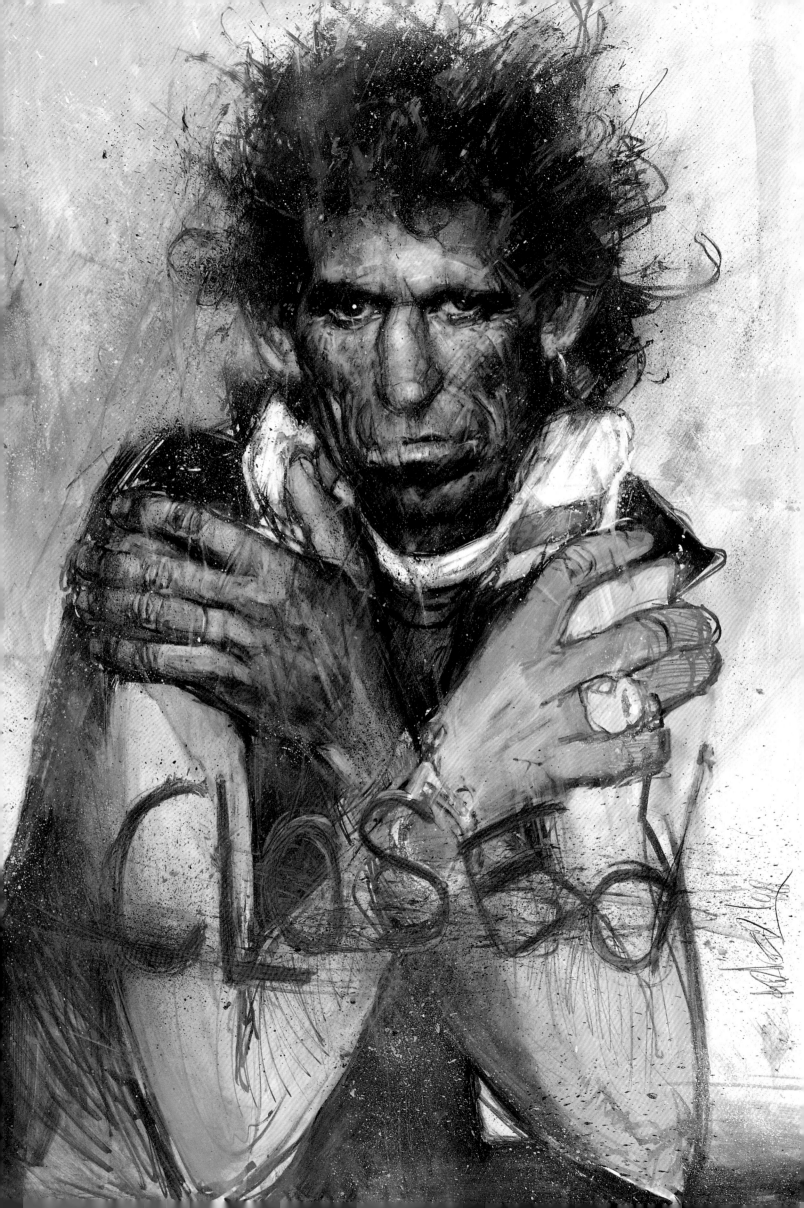

List of paintings/Bildregister

Quotations

William S. Burroughs
(born 1914 in St. Louis/Missouri), writer and author off
such world-famous books as "Junky", "Naked Lunch" and
"The Western Lands". The main subject of his very autobio-
graphical stories are the manipulations and nightmares of
people in highly civilized societies. His work influenced
authors like Charles Bukowski as well as numerous musici-
ans. Made records with the performance-artist Laurie
Anderson and the band "Material". Friends of Tom Waits
and Keith Richards.

Chet Flippo
Journalist and contributor to the American musicmagazine
"Rolling Stone".

Jerry Faye Hall
(born 1956 in Gonzales/Texas), top model and life
companion of Mick Jagger. Mother of two children she has
with Jagger.

Patti Hansen
(born 1959 in Staten Island/N.Y.), model and wife of
Keith Richards. Mother of two children she has with
Richards.

Steve Jordan
Musician. Member of Keith Richard's Band "Expensive
Winos".

Alexis Korner
Musician and promoter of England's first Blues Band
"Blues Incorporated". Members included Brian Jones and
Charlie Watts.

Richard Lloyd
Musician and member of the band "Television".

Lisa Robinson
Journalist, writes for "Hit Parader" and other magazines.

Bono Vox
Singer of the Irish band "U 2".

Tom Waits
Musician and actor.

Andy Warhol
(1928-1987), painter, photographer, film producer and
star of New York's society. Leading exponent of Pop Art.
His screen prints of self portraits and portraits of celebrities
made him internationally famous and rich.

Zitate

William S. Burroughs
(geb. 1914 in St. Louis/Missouri), Schriftsteller und Autor
weltberühmter Bücher wie „Junkie", „Naked Lunch" und
„Western Lands". Zentrale Themen seiner stark autobio-
graphisch gefärbten Werke sind die Manipulationen und
Alpträume, denen Menschen in hochzivilisierten
Gesellschaften ausgesetzt sind. Seine Arbeit beeinflußte
Schriftsteller wie Charles Bukowski ebenso wie zahlreiche
Musiker. Plattenaufnahmen mit der Performance-Künstlerin
Laurie Anderson und der Band „Material". Befreundet mit
Tom Waits und Keith Richards.

Chet Flippo
Journalist und Mitarbeiter des amerikanischen Musik-
Magazins „Rolling Stone".

Jerry Faye Hall
(geb. 1956 in Gonzales/Texas), Top-Model und Lebens-
gefährtin von Mick Jagger. Mutter zweier gemeinsamer
Kinder mit Jagger.

Patti Hansen
(geb. 1959 in Staten Island / N.Y.), Foto-Model und
Ehefrau von Keith Richards. Mutter zweier gemeinsamer
Kinder mit Richards.

Steve Jordan
Musiker. Mitglied von Keith Richards Band „Expensive
Winos".

Alexis Korner
Musiker und Gründer von Englands erster Blues-Band
„Blues Incorporated". Mitglieder u.a. Brian Jones und
Charlie Watts.

Richard Lloyd
Musiker und Mitglied der Band „Television".

Lisa Robinson
Journalistin. Schreibt u.a. für „Hit-Parader".

Bono Vox
Sänger der irischen Band „U 2".

Tom Waits
Musiker und Schauspieler.

Andy Warhol
(1928-1987), Maler, Fotograf, Filmemacher und Star der
New Yorker Gesellschaft. Hauptvertreter der sog. Pop-Art.
Seine Siebdrucke von Selbstportraits oder den Portraits
der „Oberen Zehntausend" machten ihn weltberühmt und
reich.

Source Notes

Page
10 "Mick Jagger - Primitive Cool" by Christopher
 Sandford; Victor Gollancz, London
14 / 82 "The Works" by Ron Wood;
 Fontana Paperbacks, London
18 / 90 "The Western Lands" by William S.
 Burroughs; Viking Penguin Inc., London
66 "Junky" by William S. Burroughs;
 Penguin Books Ltd., London
60 "The Andy Warhol Diaries"; Pan Books,
 London, Sidney and Auckland
82 "Stone Alone" by Bill Wyman and Ray Coleman;
 Penguin Books Ltd., London
all other quotations: "Keith Richards" by Victor Bockris;
Hutchinson, London

Quellennachweis

Seite
10 „Mick Jagger" von Christopher Sandford;
 Wilhelm Goldmann Verlag, München
14 / 82 „The Works" von Ron Wood; Fontana
 Paperbacks, London (dt. Übersetzung für diese
 Ausgabe: Andrea Faustmann)
18 / 90 „Western Lands" von William S.
 Burroughs; Limes Verlag im Verlag Ullstein GmbH,
 Frankfurt a.M./Berlin
66 „Junkie" von William S. Burroughs; Verlag Ullstein
 GmbH, Frankfurt a.M./Berlin
60 „Das Tagebuch" von Andy Warhol; Droemersche
 Verlagsanstalt Th. Knaur Nachf., München
82 „Stone Alone" von Bill Wyman und Ray Coleman;
 Wilhelm Goldmann Verlag, München
alle anderen Zitate entnommen aus: „Keith Richards" von
Victor Bockris; Wilhelm Heyne Verlag, München.

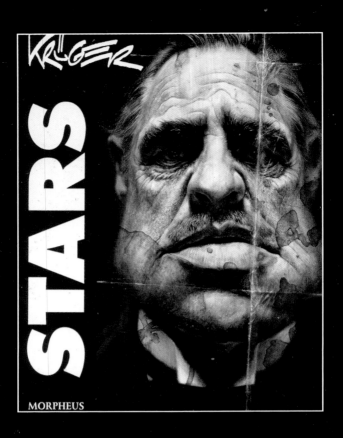
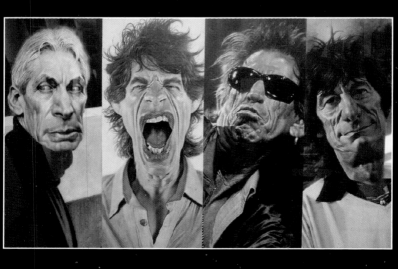